On Tour With
THOMAS TELFORD

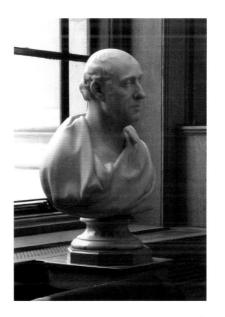

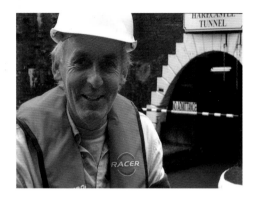

Chris Morris took up photography after dropping out of university. The late Sixties saw him working for Italian magazines who were avid for images of the London arts and hippy scene.

After three decades of corporate photography he moved to Gloucestershire and reverted to documentary work, linking it to his long interest in industrial history. He has held several exhibitions of his work and published a number of books, including:

Work in the Woods
A celebration of the Forest of Dean's industrial legacy

Under Blorenge Mountain
Exploring the Blaenavon World Heritage Site

The Great Brunel
Photographing the legacy of the great Victorian engineer

A Portrait of the Severn
Evocative images of Britain's longest and most important river

On Tour With

THOMAS TELFORD

Chris Morris

Introduction by
Neil Cossons, former Chairman of English Heritage

AMBERLEY

To my daughter Rachel, who travelled with me on my first iron bridge tour in 1980

First published 2004 by Tanners Yard Press
Third edition 2015

Amberley Publishing
The Hill, Stroud
Gloucestershire, GL5 4EP

Designed by Paul Manning
Printed in the UK

British Library Cataloguing in Publication Data
A catalogue record for this book is available from the British Library

ISBN (PRINT) 978 1 4456 5057 9
ISBN (E-BOOK) 978 1 4456 5058 6

Page 1: Bust of Thomas Telford at the Institution of Civil Engineers
Page 6: The Menai Bridge with Snowdonia in the background
Page 8: The Caledonian Canal at Moy
Note: For reasons of historical context, some Welsh placenames in the book appear in their anglicised version.

Contents

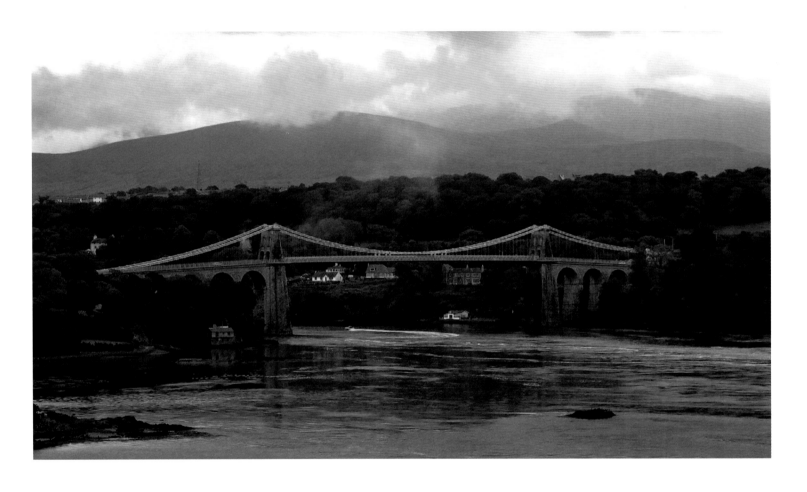

'It is more by the performance of useful works than the enjoyment of splendid orders I wish my name to be known'

Thomas Telford, on hearing he had been knighted by the King of Sweden

Preface to the third edition

This book is a visual celebration of Thomas Telford's engineering and architecture, much of which remains today. It is not intended to be a complete catalogue; while all the major works are included, many minor ones are not (particularly in Scotland, where there are literally hundreds of road bridges and dozens of churches to be found). There is little mention of work which no longer exists.

The book's title, *On Tour with Thomas Telford*, is a reflection of the great man's itinerant lifestyle and suggests a geographical format. But it also flows roughly chronologically – many of the projects took several years to realise and so ran concurrently. The book is not academic or technical, but each chapter provides enough information to view the images in context.

If Telford were able to tour the country today he would find many changes to his works – bridges widened and strengthened, harbours extended, churches embellished; he would also find canals meticulously maintained (though nowadays for recreation rather than commerce). He would come upon other bridges that, bypassed, stand as monuments to his genius, and if he visited his churches at Mallinslea and Madeley he would find himself in the centre of a modern metropolis named after him.

I have not disguised these changes for I believe that despite them Telford's original concepts shine through. Neither have I tried to isolate his works in a time warp: in fact, I have embraced facets of modern life that happily interact with his two-hundred-year-old legacy.

For this third edition I have added material from Scotland, previously published in *Thomas Telford's Scotland*, thus providing more chances of enjoying the discovery of tiny churches in Highland Glens and the pretty harbours of the far north. Nothing could be more appropriate for a man whose life was dedicated to his work than to view his achievements as a kind of visual biography. I hope that through this book many more people will appreciate this great man and perhaps salute him with tours of their own.

On Tour with Thomas Telford, has been out of print for two years and I am indebted to Amberley Publishing for making this new edition available.

Chris Morris, May 2015

Facing page: The Menai Bridge.

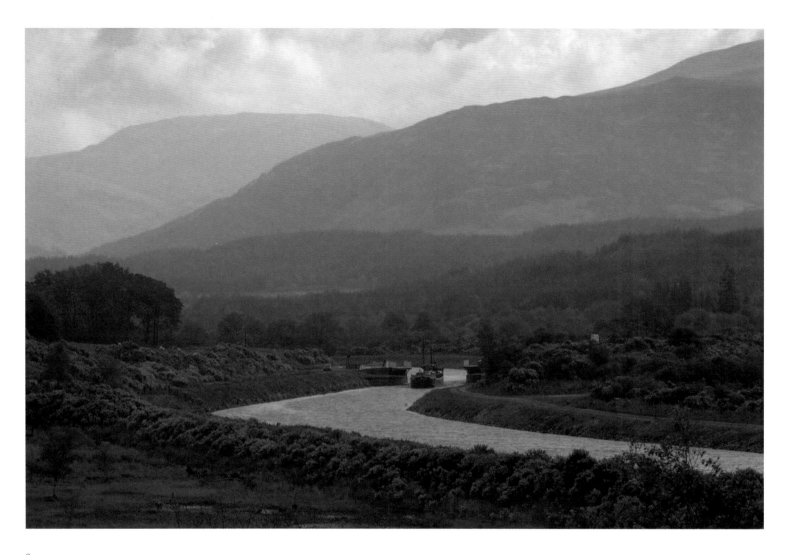

INTRODUCTION

Thomas Telford was one of the giants of his age, a man of boundless energy and intellectual curiosity who helped to define the nineteenth century as the heroic age of engineering. The first President of the Institution of Civil Engineers, Telford more than any other established engineering as a profession. And two hundred years later, today's engineers would find his practices familiar; his ability to design, specify and delegate and to put together a team of trained and trusted surveyors, foremen and masons. In this way his prolific output could be translated into the abundance of great works that span the country and by which we now recognise and revere him.

In this book Chris Morris brings to life through his vivid portfolio of photographs the bold inventiveness of a man whose genius can be appreciated as much for its elegance and artistry as its engineering vigour. At the time of their building Telford's works commanded awe and esteem. They conferred certainty on the emerging world of industrial and mercantile prosperity by forging the essential links on which trade and commerce could depend. And they fuelled the debate on the sublime and the picturesque which absorbed the attentions of contemporary writers and artists. Of the entrance to the Caledonian Canal, which he visited with Telford in 1819, Southey wrote: 'Here we see the powers of nature brought to act upon a great scale, in subservience to the purposes of men.' Telford's roads, bridges, canals and harbours demonstrate clearly and powerfully the triumph of mankind over nature in the interests of creating a universal good.

It is this absence of ambiguity that sets Telford's works apart. That spirit of unbridled self-confidence is as compelling today as when they were built, a generation or more before the horrors of industrialisation that have clouded our view of the middle years of the nineteenth century. A passage through the Caledonian or Gotha canals or along the Wales section of the Holyhead Road exhilarates as no other. But if at the time Telford was affirming a mastery over the physical world, today his works, softened by time and nature, enjoy an extraordinary affinity with the landscapes of which they form part. Almost without exception his engineering design complements rather than despoils. If there are exceptions, they were never built. His proposal for spanning the Avon Gorge in Bristol – with 'Gothic' towers rising from the water's edge – is difficult to take seriously, whereas what is arguably his masterpiece, the crossing of the straits of Menai, must stand as one of the great works of art and engineering of all time.

Throughout, Chris Morris draws on detail to emphasise this apparent sensitivity to setting and place. Telford was an enthusiastic proponent of cast iron for bridge construction, perfecting at Bonar, at the head of Dornoch Firth, a design he was to use again at Craigellachie, and later at Esk Bridge, Carlisle and Mythe Bridge, Tewkesbury. But it was at Bettws-y-Coed that he adapted this pattern for the dramatic setting of the Conwy valley to shrewdly celebrate in slogan and symbols Wellington's victory at Waterloo, on a road paid for by government funds in order to ease the journey for Irish parliamentarians travelling from Dublin to Westminster. The giant cast-iron roses, thistles, leeks and shamrocks that fill the spandrel frames represent a rare departure into decoration.

There was more to Telford than meets the eye. But what Chris Morris has so beautifully captured here meets the eye in a most seemly manner. It is a prelude to the tour that must follow.

Neil Cossons,
former Chairman of English Heritage

Facing page: The Caledonian Canal at Moy.

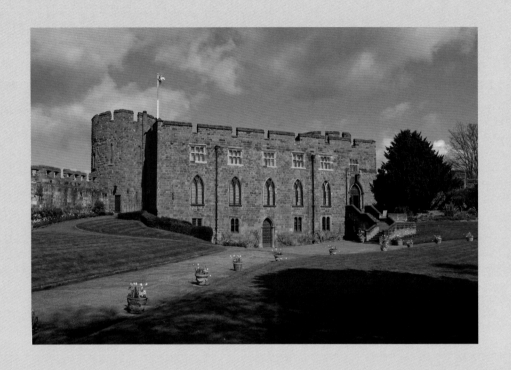

Early Work: Mason and Architect

Thomas Telford was born in 1757, in an isolated cottage north of Langholm in the Scottish borders; within months his father, a shepherd, had died. It is difficult to imagine a tougher start in life. With the help of an uncle, Telford attended parish school; the benefit of an education was at least matched by the lasting friendships he made, which served him well throughout his life.

Telford was apprenticed to a stone mason in Langholm, and developed an ambition to be an architect. He furthered his prospects first with a spell in Edinburgh's burgeoning 'New Town', then in London, where he worked as a mason on Somerset House. His good luck was linked to the rocketing social status of his childhood friend William Jackson, who married an heiress from Bath, adopted his new wife's name, Pulteney, and became one of the wealthiest men in the country. Through his friendship with Pulteney, Telford secured a foreman's job on works at Portsmouth dockyard. Crucially, the same connection precipitated his move to Shrewsbury in 1787.

Shrewsbury

William Pulteney chose to live in the rather ruinous Castle, part of his estate, and rebuilding it was Telford's first task. Another early project in the town was to improve the county gaol: Telford revised the plans after meeting the prison reformer John Howard, whose humanity made a deep impression on him.

Churches and bridges

Nothing had so far disturbed Telford's architectural ambitions, exemplified by churches he was responsible for at Madeley and Mallinslea (in the modern town of Telford) and at Bridgnorth. However, by 1788 he had been appointed County Surveyor with the responsibility for Shropshire's roads, and bridges.

His first bridge (since his journeyman work at Langholm) was at Montford. Also over the Severn, after the floods of 1793, he replaced those at Bewdley and Bridgnorth, sturdily workmanlike in stone and still in use today. But more significant was the new bridge at Buildwas, now sadly replaced. Just down the Severn, an inescapably short distance away at Coalbrookdale, stood famously, then as now, The Iron Bridge. Telford would have seized on this example of what could be achieved with the new material, cast iron, and looked to exploit its potential. Buildwas gave him a chance; arguing for a single span for ease of navigation and flood resistance, he made it both longer and lighter than the pioneering arch at Coalbrookdale.

Canals

His bridge-building might lead us into thinking Telford was changing his career, but it was a further development which was to become the turning point. In 1793, while still at Shrewsbury, he was appointed 'general agent, engineer and architect' to the newly formed Ellesmere Canal Company.

Facing page: Shrewsbury Castle.

Telford's birthplace near Langholm in the Scottish borders was a bleak area of tumbling streams and high sheep pasture. His early work included the gravestone (*left*) for his father in the burial ground at Westerkirk.

In the town itself is a stone doorway by Telford (*above*), probably made as a training exercise.

Before he headed south to seek his fortune, Telford worked as a mason in Edinburgh New Town (*above*).

Facing page: Boys throw stones into the Esk at Langholm Bridge, where Telford worked as an apprentice mason.

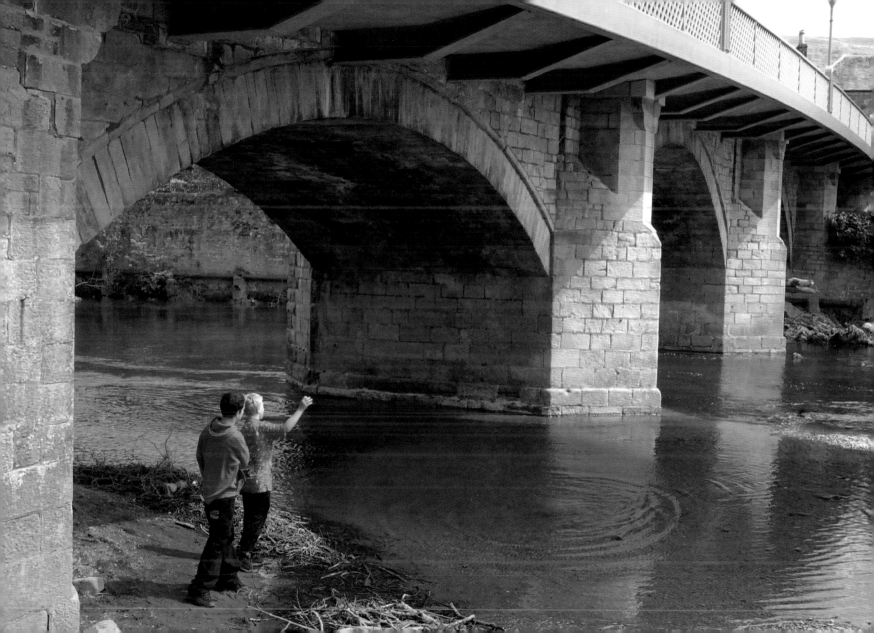

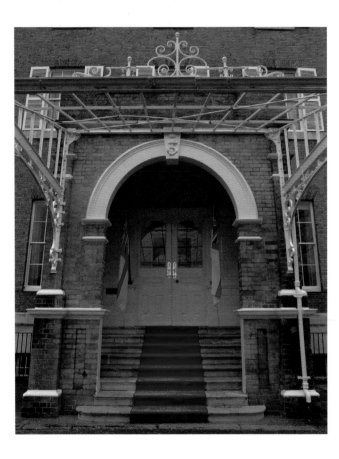

Far left: The south-west corner of Somerset House in London, where Telford worked as a mason.

In Portsmouth Naval Dockyard, Telford was employed as superintendent for new buildings, including the chapel, St John's Church (*facing page*).

Left: The brief for the Commissioner's House – today the home of the Second Sea Lord – included its 'suitability for the reception of Royal visitors'; the red carpet may be a later touch.

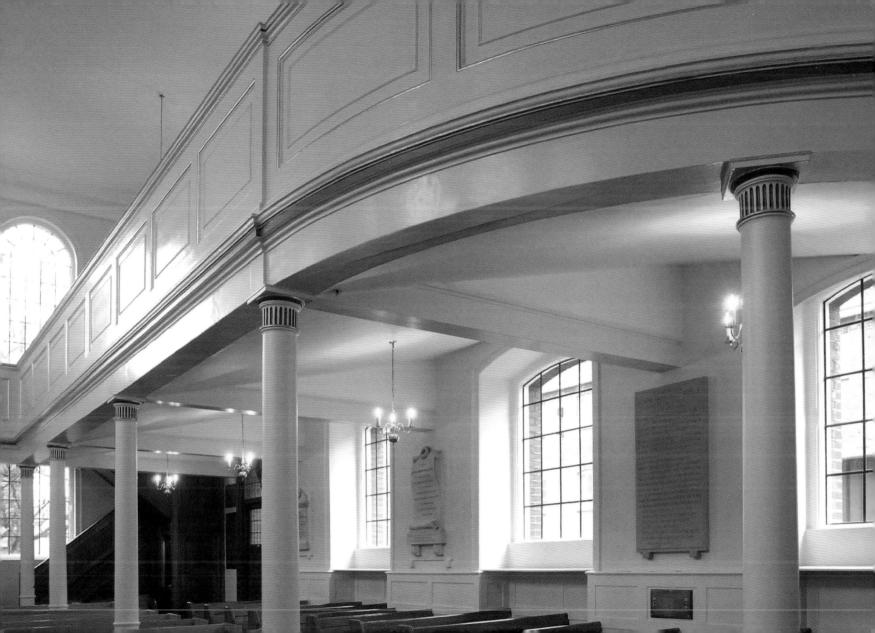

While at Shrewsbury, Telford rebuilt the gaol (*facing page*) and the castle (*left*).

Above: Under the influence of the penal reformer John Howard, who felt prisoners should be given meaningful employment (and whose bust sits in the niche above the gaol entrance), Telford used convict labour to help with archaeological excavations at the nearby Roman site of Uriconium (Wroxeter).

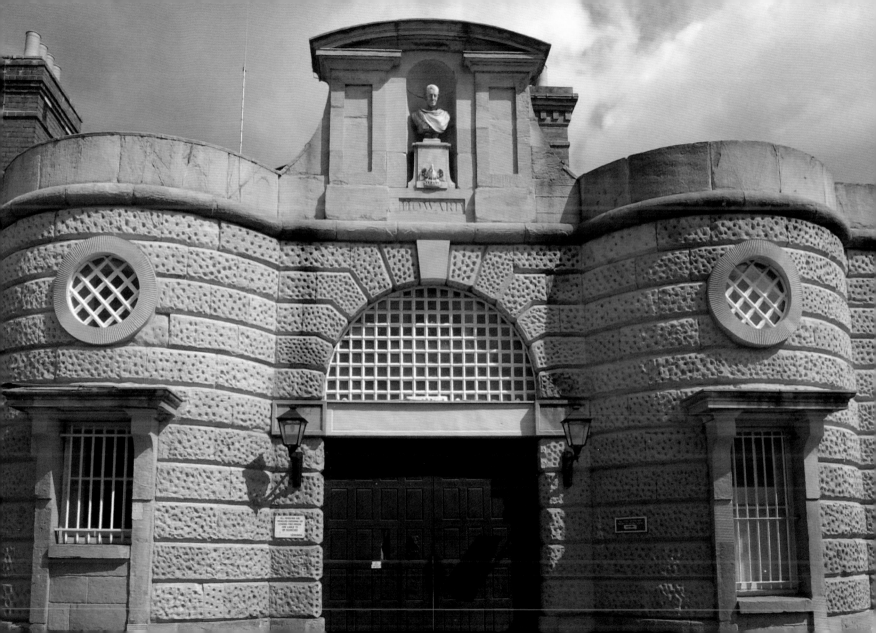

In 1792 Telford built Montford Bridge (*facing page*), his first since apprentice work in Langholm. The date stone reads 1792. Further upriver, on Pulteney's estates at Haimwood (*right*), he supervised works to control flooding of the low-lying meadows - a series of 'levées' (known locally as 'argys') and a drain still known as New Cut.

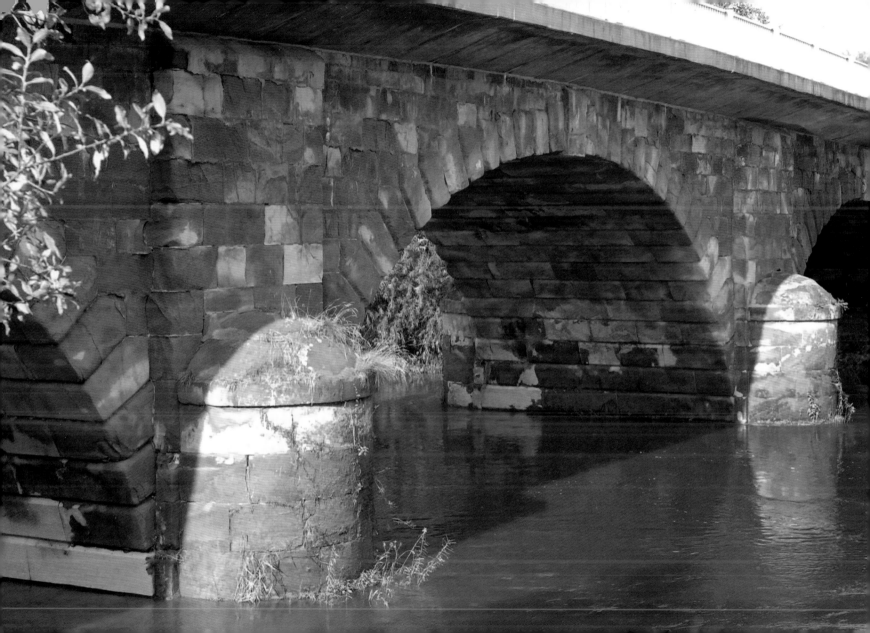

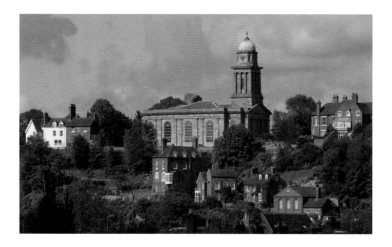

Telford's first bridge over the
Severn at Montford was built in
1792. Those at Bewdley (*facing
page*) and Bridgnorth (*right*)
followed three years later.

Also at Bridgnorth, St Mary
Magdalene (*above*) was Telford's
first church in Shropshire.

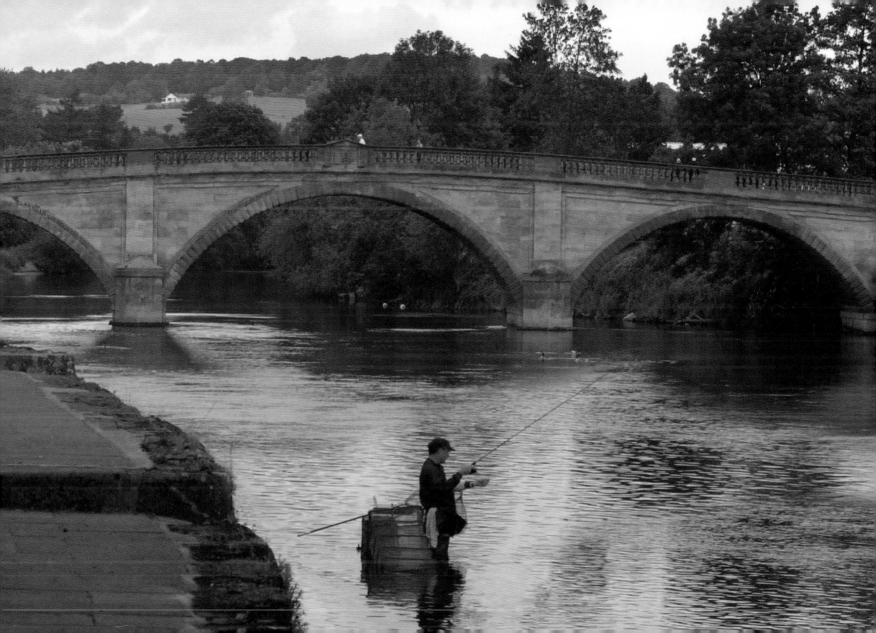

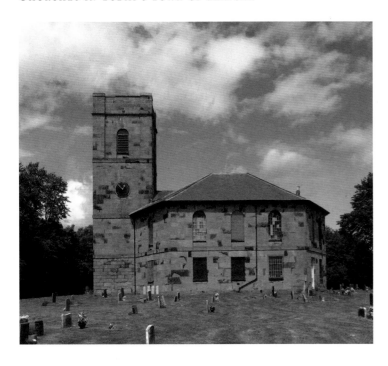

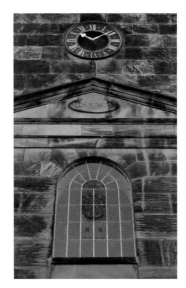

St Leonard's, Mallinslea (*above*), and St Michael's, Madeley (*above right, right and facing page*). The mosaic floor may be a later addition.

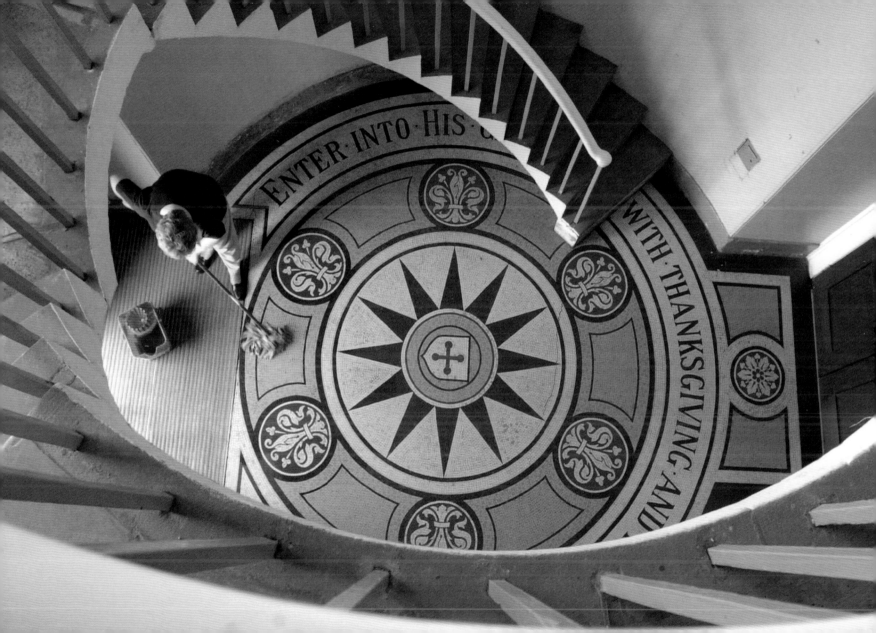

Right: five iron caps define the position of the ribs of Telford's first iron bridge at Buildwas; above them, the modern crossing rises from the old stone abutments. A remnant of one of the outer ribs with the date cast in it survives as a memorial (far right).

Below right: an 1818 bridge from Cound, removed and renovated, carries a footpath in Telford town centre.

Facing page: Aston Cantlop, 1813, is the only Telford-designed Shropshire iron bridge remaining in situ.

Buildwas was cast at Coalbrookdale, while the later ones were in partnership with William Hazeldine.

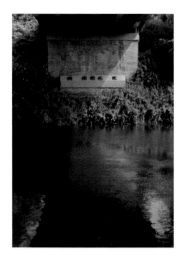

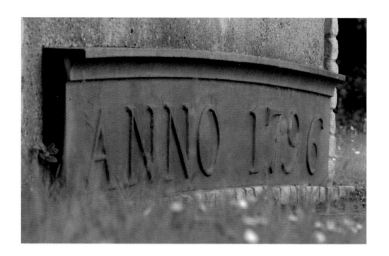

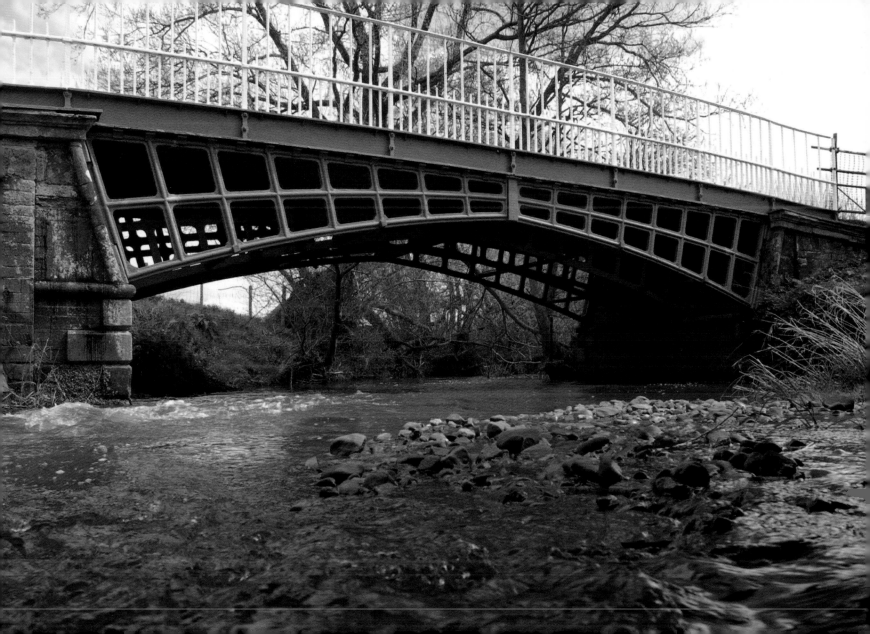

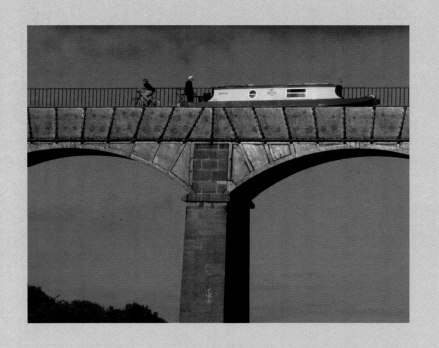

ELLESMERE CANAL: A CAREER SHIFT

Shrewsbury Canal

While the planning of the Ellesmere Canal was still in its infancy, Telford's services were sought by the in-progress Shrewsbury Canal (whose engineer had died). One of the works on this route was an aqueduct over the River Tern at Longdon; work had progressed to a conventional brick-built approach to the river. What Telford added to this was nothing short of revolutionary.

The accepted way of building aqueducts, inherited from the original canal master-builder James Brindley and practised unamended by his successors, Jessop and Rennie, was to make massive structures substantial enough to be lined with a thick layer of puddled clay. Telford was prepared to experiment with iron, the new material; at Longdon he created an iron trough made of flanged and bolted plates, supported by an iron frame.

Ellesmere Canal

The Ellesmere Canal company had an ambitious plan to link the Mersey and the Dee with the Severn. Much debate about routes and survey work had already taken place when, in 1793, they appointed Telford. His position was secondary to the Chief Engineer, William Jessop, of another generation, with long experience and a high reputation as a canal builder; nevertheless it was Telford's remit to plan and build the canal, with the older man taking a monitoring role. While the novice must have learnt a lot from the master, credit for the great works that followed belong to the younger man.

The Ellesmere never met its aims. Its plan to push north up the west side of the Dee (to serve the rich industrial area of Ruabon and Wrexham) was abandoned in favour of a tramway, and its southern line, heading for the Severn, ended ignominiously at a wharf near the village of Weston Lullingfields. The northern link from Chester to the Mersey was built, and the planned branch through Ellesmere to Whitchurch was extended to reach the Chester canal just north of Nantwich. Thus a rather strange diversionary route was created from Llangollen to the Mersey. But before the original line was aborted Telford had conceived and built a wonder of the age – the Pontcysylllte Aqueduct – by which the canal crossed the Vale of Llangollen.

The drawings for Pontcysyllte pre-date Longdon, which which had been built first, and could be seen as a testbed for Telford's ideas. At 120 feet above the River Dee, Pontcysyllte was too high for an iron frame to be feasible; this time, arches made of flanged and bolted iron ran beneath the trough, supported in turn on slim, tapering stone columns made possible by the relative lightness of the canal above.

Plas Kynaston

In admiring Telford's new structures it would be wrong to ignore his collaborator William Hazeldine, who supplied all the cast iron for these works. Hazeldine's foundry was Plas Kynaston, directly linked to the canal at the north end of Pontcysyllte.

Facing page: Pontcysyllte.

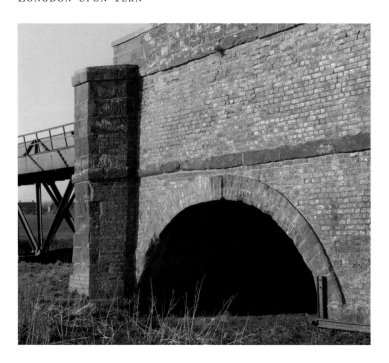

William Clowes had started to build an aqueduct to carry the Shrewsbury canal over the River Tern, using a conventional squat and heavy design to take the weight of the puddled clay which would line the canal bed (*above*).

Telford took a radically different approach: his use of flanged and bolted iron plates was an unprecedented and revelatory use of the new material. The towpath (*above right*) is slung alongside the main structure.

The aqueduct, standing unannounced in farmland (*facing page*), is a classic monument to industrial progress.

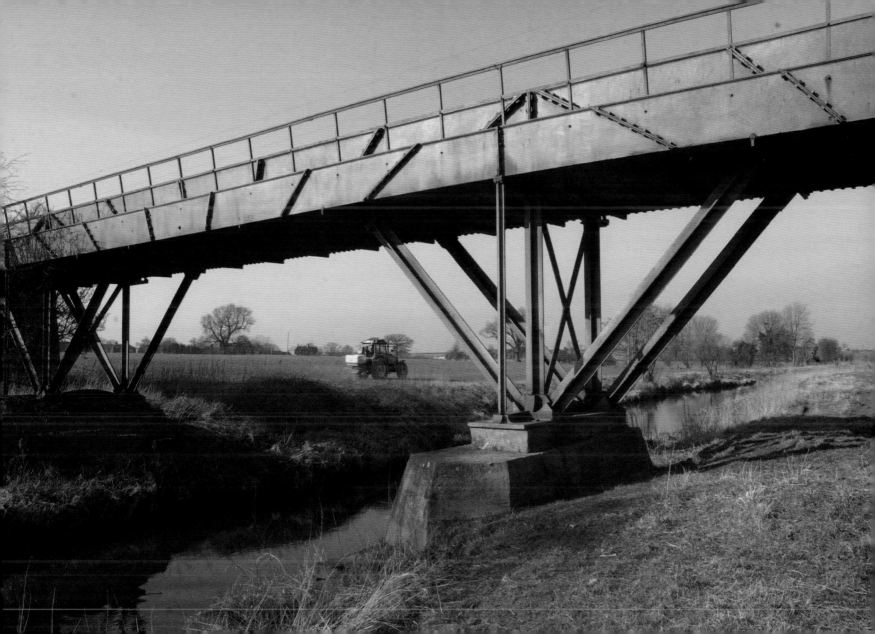

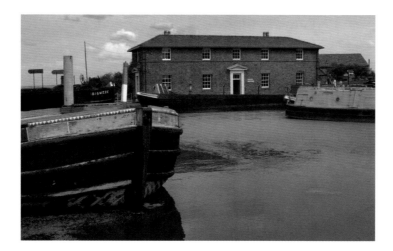

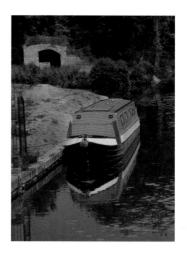

The Ellesmere canal failed in its objective to reach Shrewsbury and the Severn, terminating near the village of Weston Lullingfields. Today the hamlet of Weston Wharf still boasts a wide green ditch and a building that appears to owe more to commerce than agriculture (*left*). This probable warehouse may have seen the transit of the wrought-iron chains from Hazeldine's forge near Shrewsbury en route to the Menai Bridge.

The Carreghofa branch was built to serve the limestone industry at Llanymynech (*right*) and joined onto Newtown's Montgomery canal. The 1802 Toll House (*above*) is the only Telford building left at Ellesmere Port, the northern terminus of the canal and today home to the National Boat Museum.

Facing page: Horseshoe Falls, west of Llangollen on the River Dee, provides the water supply for the Ellesmere canal.

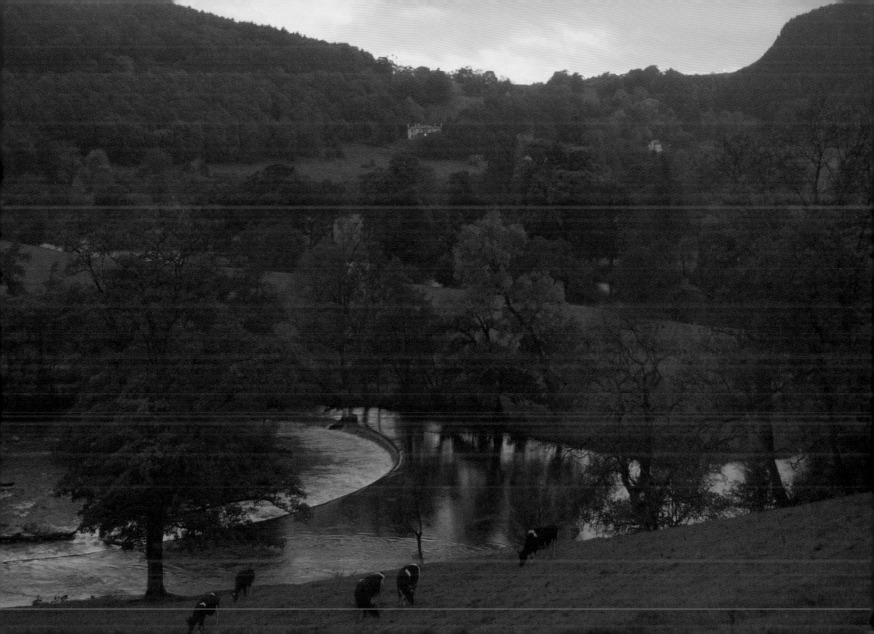

To the east of Llangollen and immediately north of Pontcysyllte, Trevor was an important wharf in Telford's day (and still is, for holiday traffic).

The archway (*top right*) may have taken a canal extension to Plas Kynaston, William Hazeldine's iron foundry – a perfect location for building the aqueduct.

The route north to Ruabon, originally planned to be served by the Ellesmere canal, was connected by a tramway (*bottom right*).

The house Telford is reputed to have stayed in when visiting Plas Kynaston and Pontcysyllte is now a public house named 'The Telford'. The fanlight (*above right*) celebrates the connection.

Just below Trevor, a Telford tourist can enjoy breakfast with a grandstand view of the aqueduct at Elaine's B & B (*right*).

Facing page: There are several iron and stone hybrid bridges at Trevor Basin; instead of being built on timber centering, which was removed on completion, stonework was supported on arched cast-iron beams which were left in place.

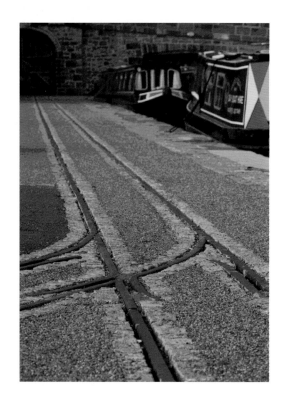

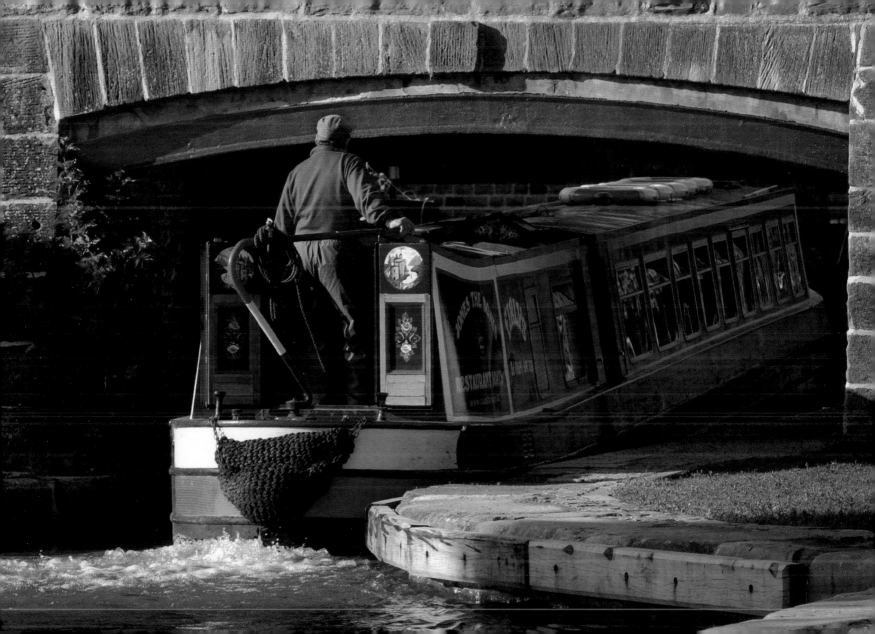

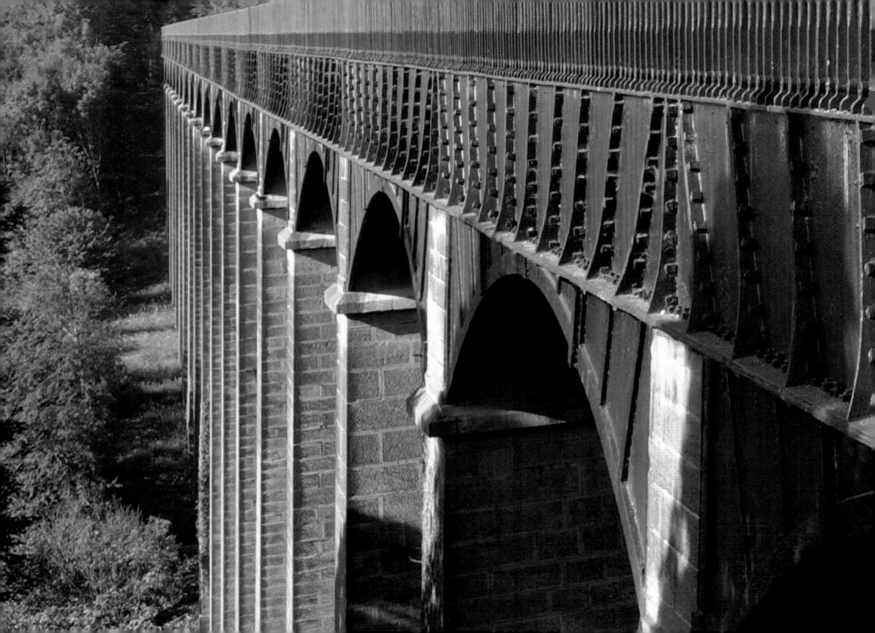

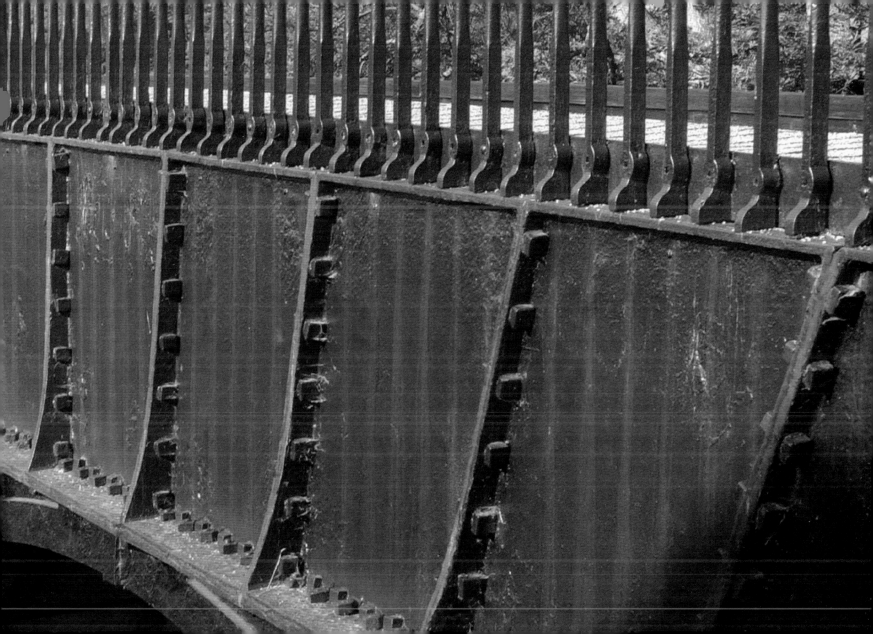

Previous page: The aqueduct viewed from Trevor Basin.

This innovative structure, opened in 1805, is discussed on page 27. With the vision required for such a break with convention, Telford's design took engineering to a new level. Indeed, in *The Iron Bridge*, Neil Cossons and Barrie Trinder describe it as 'a monument of the Romantic Movement as well as the Industrial Revolution.'

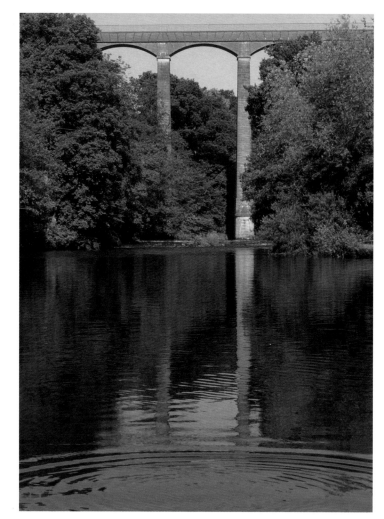

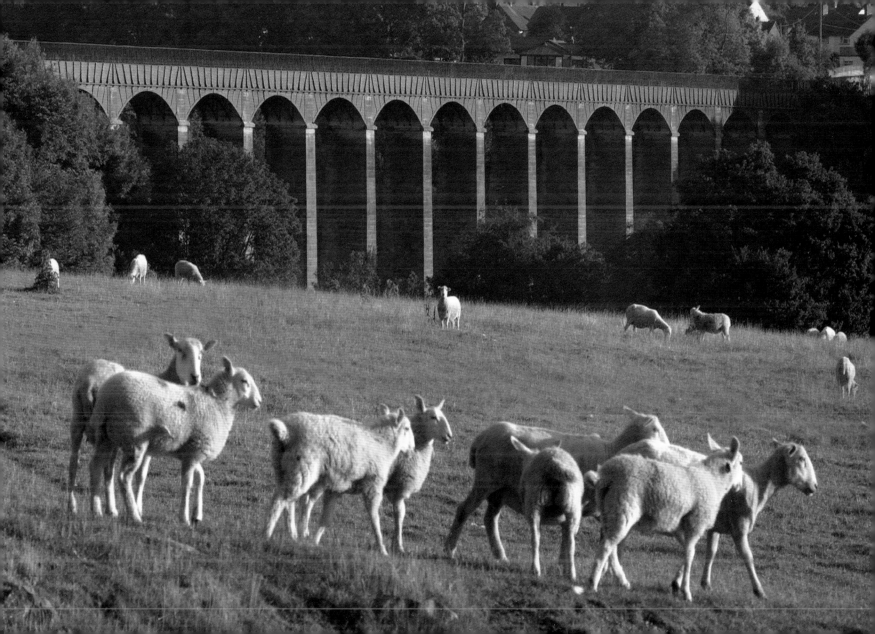

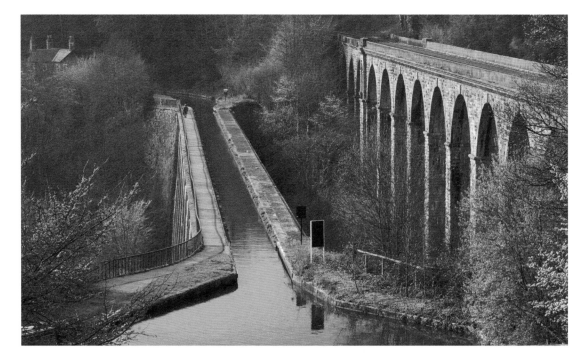

Above and facing page: To the south of Pontcysyllte is the Chirk aqueduct, its limelight stolen by its more famous neighbour. What appears to be a conventional viaduct is strong enough to carry the canal by virtue of using iron plates instead of puddled clay as its base. Flanged and bolted sides were added later to form a complete trough. The railway runs a parallel course over the River Ceiriog. Immediately to the north, the canal runs through a short tunnel (*above*) which uniquely at the time included a towpath.

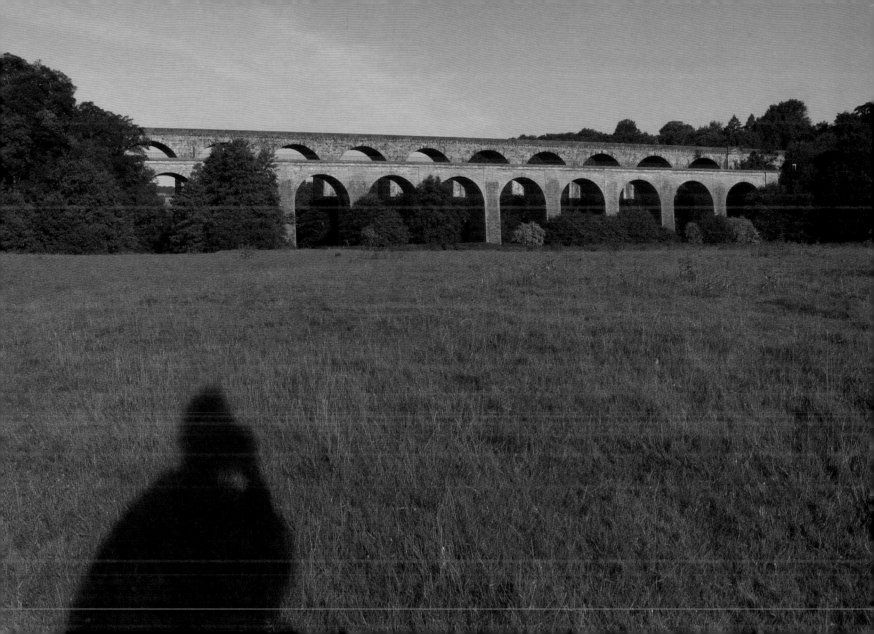

The wharf (*facing page*) serving the town of Ellesmere is on a short spur from the main line. At the junction (signpost, *far right*) is the house (*above*) that was built as the company offices.

Beyond the offices stand the original workshops (*right*), now used by British Waterways, with two centuries of alterations in evidence. The original dry dock (*above right*) is today used by a commercial pleasure boat company.

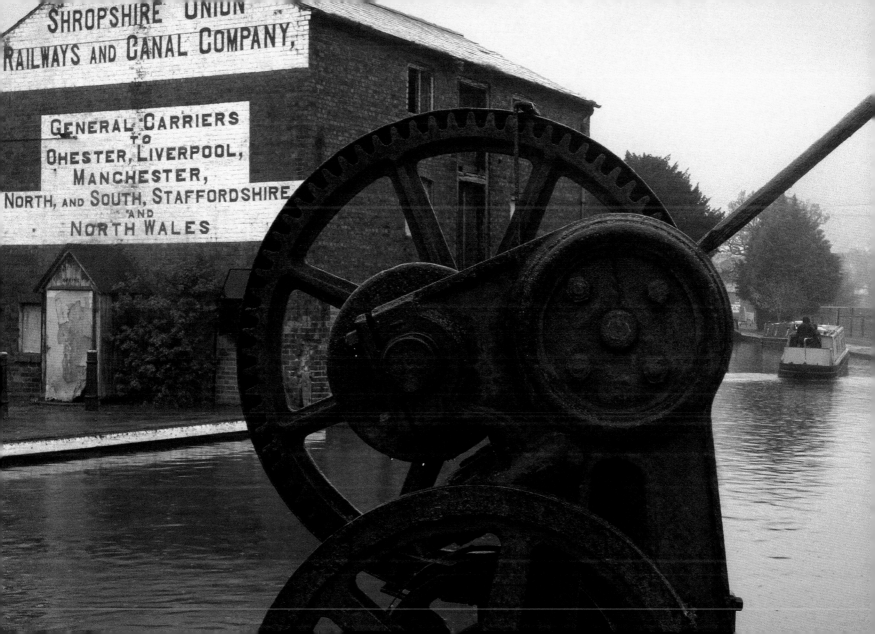

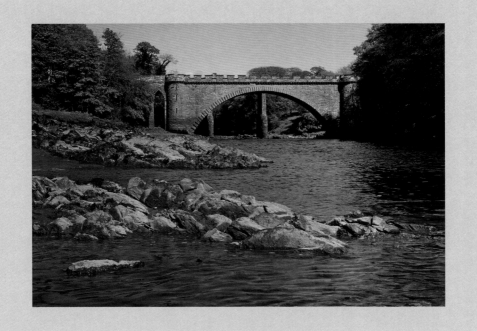

3

RETURN TO SCOTLAND

Towards the end of the eighteenth century Westminster began to relent on the very harsh conditions that had been imposed on the Scots after the defeat of Bonnie Prince Charlie in 1745. One initiative was the setting up of a 'British Fisheries Society': by improving harbours, which were generally in a poor state, and building new ones, it was hoped that a fishing industry could be generated, with herring being the plentiful and nourishing catch. However, it was perceived that helping fishermen by improving their harbours would lead to nothing if the herring catch could not reach its markets – a real problem as the roads at that time were dire. William Pulteney was a member of the Society and was to ensure that his childhood friend Telford had a part to play.

The largely ruinous remains of Wade's military roads were the nearest thing to a road network: apart from their poor state, they were built to suit armies marching from the south rather than fishermen wanting to trade inland. Thus an ambitious road-building programme was undertaken which saw Telford plan and engineer something approaching a thousand miles of road, linking the far north-east and north-west coasts with the lowlands, and on to England. This included the need for hundreds of bridges, some inconsequential and others grand statements such as at Pathead, and Dean in Edinburgh.

Iron does not feature greatly in Telford's work in Scotland. Apart from the swing-bridges on the Canal, the beautiful span at Craigellachie and a long-lost example at Bonar, all his bridge construction was in stone. While we can think of iron as being the new material he took and used to perfection, it is instructive to note the progress of masonry design. Even in his first Scottish bridge, Tongland, he used the technique of internal bracing walls, rather than rubble infill, for strength with lightness. Over the next two decades the visual appearance of his bridges changed from an early gloomy and gothic look to the careful detailing giving apparent lightness to Dean and Pathead.

All this work in Scotland fitted in with his many other commitments. Despite local supervision (and one of his strengths was picking able men for his team) at least once a year Telford undertook a Highland tour to personally check on progress. With thousands of miles to cover on horseback or pony-trap, no-one could have been better placed than Telford to see the need for the better road network for whose construction he later became responsible.

Facing page: Tongland Bridge.

In 1814 works were planned to replace the old turnpike road, which had become virtually impassable.

In 1825 the new road was complete; the change has been likened by the historian Roland Paxton to the construction of a new motorway today. In fact Telford's 'new' road is totally bypassed by today's A74(M), and still exists in its entirety as a quiet alternative.

Right: A remnant of the iron bridge over the Esk stands in the garden of Tully House Museum, Carlisle.

Top right: Typical bridge at Ecclefechan, with the modern road behind.

Below left and right: The only remaining milestone stands by a farm building at Dinwoodie Green (lovingly painted red by the farmer). The fine toll house at Dinwoodie is almost hidden by high hedges, and is represented here by its brass letterbox.

Facing page: Gretna is the first of eight toll houses on the road.

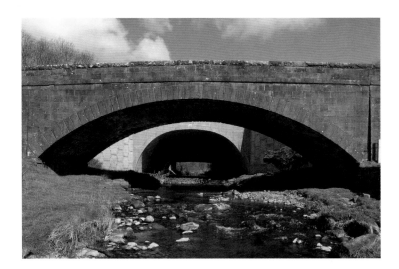

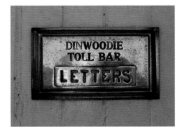

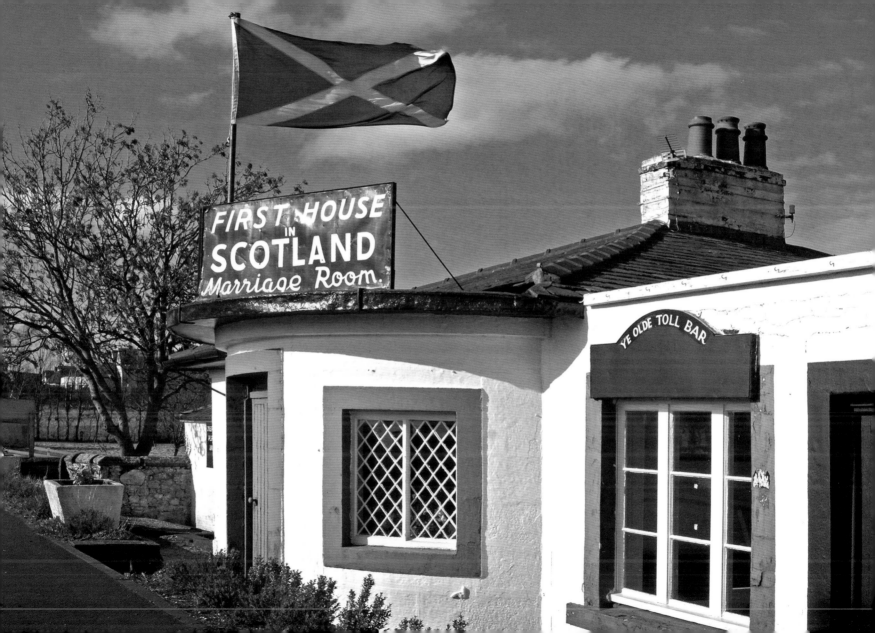

Close to the road's 1,000-ft summit at Beattock, Telford designed a coaching inn and stables (*bottom, left*). The nearby bridge is almost hidden in its tree-choked ravine but its centre roundel is in view (*facing page*), replaced on the road side of the parapet.

Right: Elvanfoot bridge crosses a headwater of the Clyde on a windswept moor.

Bottom right: A tollhouse stands abandoned beside the fine bridge at Hamilton.

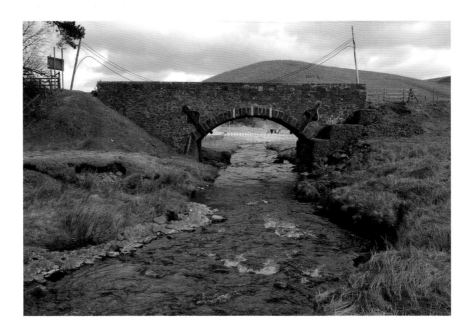

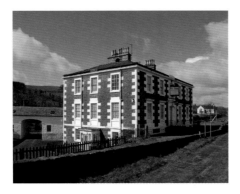

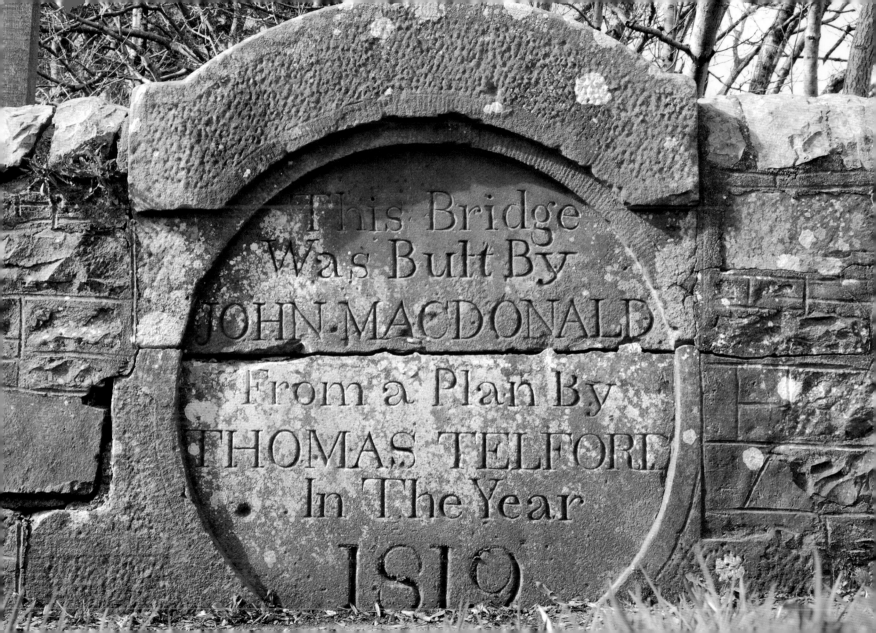

This Bridge
Was Built By
JOHN·MACDONALD
From a Plan By
THOMAS TELFORD
In The Year
1819

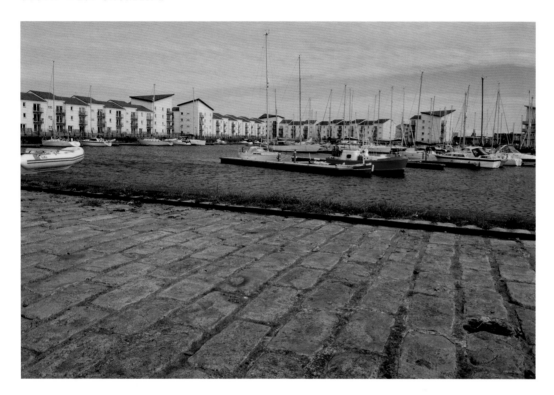

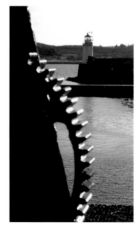

Above: Telford's Ardrossan harbour is now home to a marina.

Top right: Further north, on Bute, sections of the Glendaruel road remain.

Facing page and below right: The Crinan Canal was not built by Telford, but it was he who in 1816 supervised remedial work to correct original poor-quality contracting.

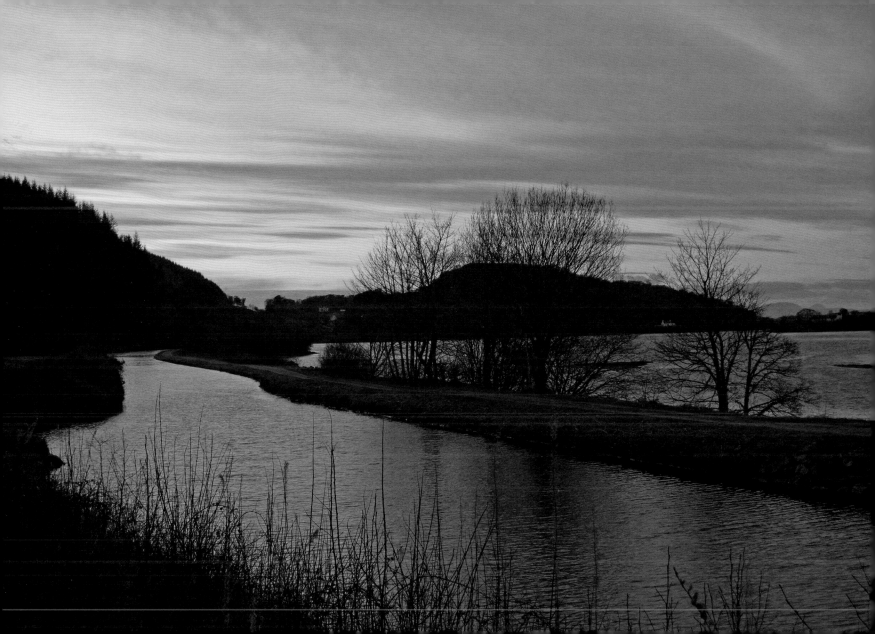

Telford took enormous trouble to keep his roads straight and level. The impressive Pathead viaduct (*facing page* and detail, *bottom left*) crosses the Tynewater valley ten miles south of Edinburgh, but a much smaller bridge, involving neither a detour nor steep gradients, would have sufficed.

To keep the road level at Falla, just to the south, a massive embankment fills the valley of the Dean Burn, with the stream diverted into a tunnel (*right*).

A comparison of a detail of Pathead with the gothic pedestrian/flood arch at Tongland, built twenty years earlier (*bottom right*), shows how Telford developed the visual appearance of his bridges. The double radius arches at Pathead give a light effect, a design shared with Dean bridge in Edinburgh.

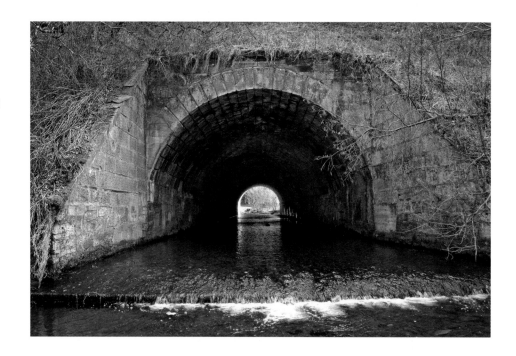

Right: A boy fishes for brown trout in the Waters of Leith, beneath Dean Bridge.

Crossing the same river is the Slateford aqueduct (*facing page*) on the Edinburgh & Glasgow Union canal, one of three similar ones using iron troughs. Telford, consultant to the project, saw no need to encase the iron with masonry, but his advice was ignored.

Top right: Emeritus Professor Roland Paxton has a collection of Telford items at his archives in Heriot-Watt University. On display behind him is an original link from the Menai Bridge.

Right: Fishermen's boats on the Glencouse Reservoir, built in 1820 for the city's water supply; Telford was consultant for the dam construction.

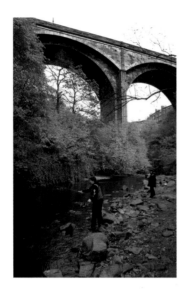

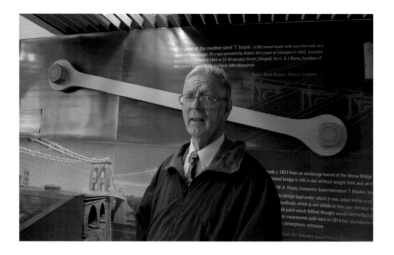

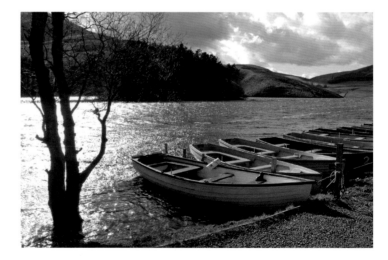

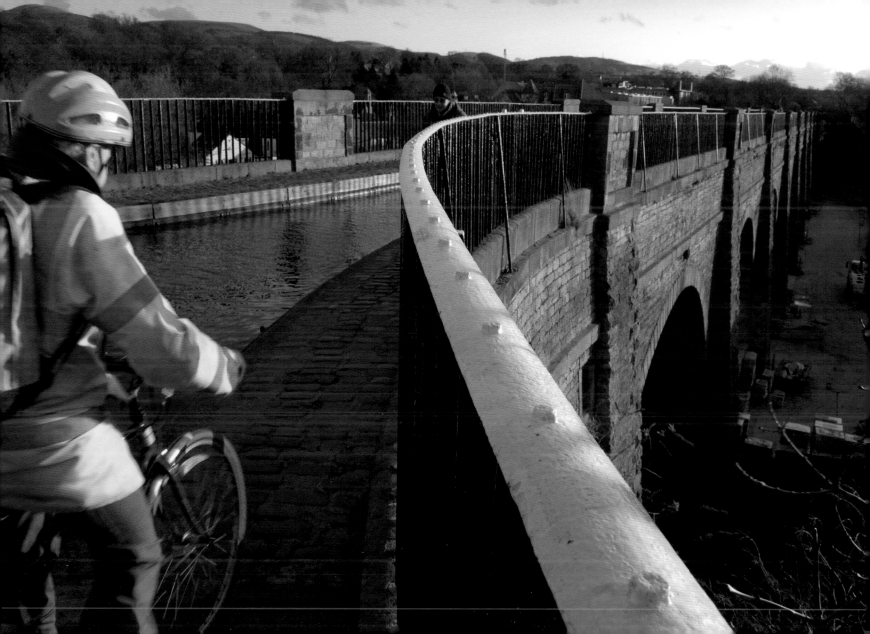

Of the three sites on Islay, Risabus (*top right*) is a ruin, while Kilmeny (*right*) and Portnahaven (*facing page*) are thriving parish churches.

Below: Members of the Board of Congregation are photographed inside Portnahaven's church. Telford's standard plan of two entrances is put to a particular use here, with one doorway used by the host village and the other by the adjoining community of Port Wemyss.

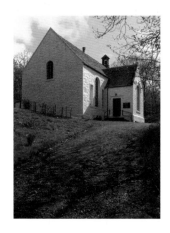

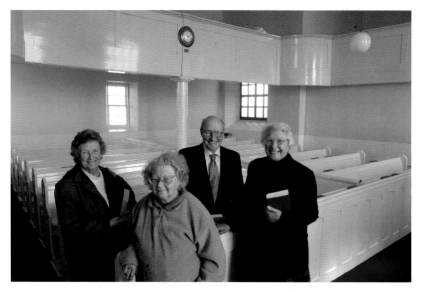

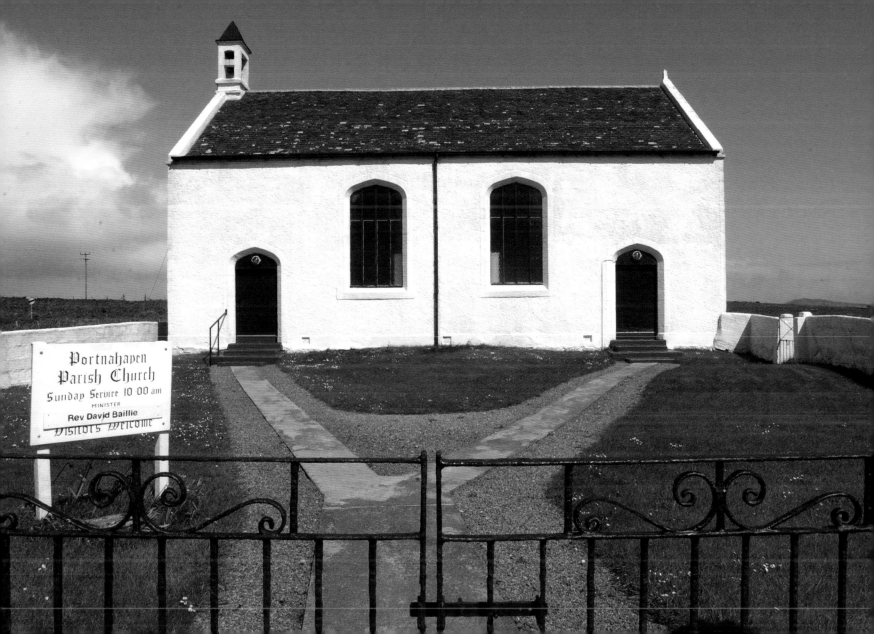

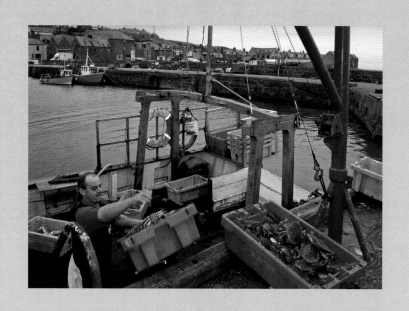

4

THE HIGHLANDS AND THE GREAT GLEN

Harbours and Canals

After the abortive rise of Bonnie Prince Charlie in 1745 the English army under Cumberland and Wade had ruthlessly crushed Scotland and destroyed the clan system, the social fabric of the Highlands. Fifty years on, London finally decided that rural Scotland, decimated and destitute, needed radical assistance, sponsoring the British Fisheries Society whose plan was to regenerate the Highland economy by encouraging fishing. One of the Society members was Telford's childhood friend, and subsequent patron, William Pulteney, who invited him to be involved in building harbours.

Although earlier in the decade Telford had built a bridge at Tongland, on the road to Stanraer, an important route to Ireland, it was Pulteney's invitation in 1796 that fully re-involved him with the country of his birth. Most of the harbour works were on the east coast where frequently fishermen were still hauling their boats up on unprotected beaches; Telford's answer was often a single jetty, providing mooring, shelter and easier unloading of the catch. In some cases improvements were made to existing facilities, sometimes on a very different scale, as at Aberdeen and Peterhead.

Caledonian Canal

Telford's workload was enormous, but individually the projects were humble – not the kind of work that would make him the most feted engineer of his generation. The exception, a plan to link the east and west coasts with a waterway big enough for seagoing vessels, was to be the Caledonian Canal. This project, spanning the years 1802 to 1822, is a singular major achievement, the fruit of vision and perseverance (despite the fact that by 1840 it was nearly closed down, not being deep enough for the increasing size of ships).

Facing page: Gourdon Harbour.

It only takes a glance at a map of the Highlands to see the fault line lying between Fort William and Inverness; contained in this natural valley, the Great Glen, are the three lochs Lochy, Oich and Ness, emptying to the sea at Loch Lynne and Beauly Firth. A waterway connecting the coasts might look an easy project; in fact, the lochs were at very different heights, and in places surprisingly shallow with hard rock beds. The engineering difficulties can be exemplified by the building of the sea locks at each end: that at Corpach, on Loch Lynne, had to be cut out of solid rock, while at Clachnaharry, the north-west exit to Beauly Firth, the masonry had to be built up from a deep bed of soft mud.

For nearly two hundred years the Caledonian canal has been flagged up as one of Telford's great triumphs. While he was the man above all others who planned and saw it through to completion, it would be wrong to ignore the genesis of the project. The first to report on the possibility of a waterway through the Great Glen was James Watt, of steam engine fame, who made a survey in 1773 for a consortium of landowners. When Telford took on the task for the government in 1802, he consulted Watt before making his own report. Meanwhile another great engineer of the late nineties, John Rennie, had made a new survey in 1793, probably for the Fisheries Society (who Telford was to work for extensively) – long time advocates of a canal. When preliminary works for construction began in 1803, William Jessop was appointed as consulting engineer, and up to his death in 1814 he and Telford worked hand in glove on the Caledonian. In his autobiography, Telford makes no mention of working with Jessop, whose own papers were lost in mysterious circumstances – a fact discussed in the epilogue to this book.

DUNKELD

One of Telford's earliest
Highland bridges, from 1804,
Dunkeld (*facing page*) replaced a
hazardous ferry over the Tay. Its
original toll house (*right*) is on
the south side

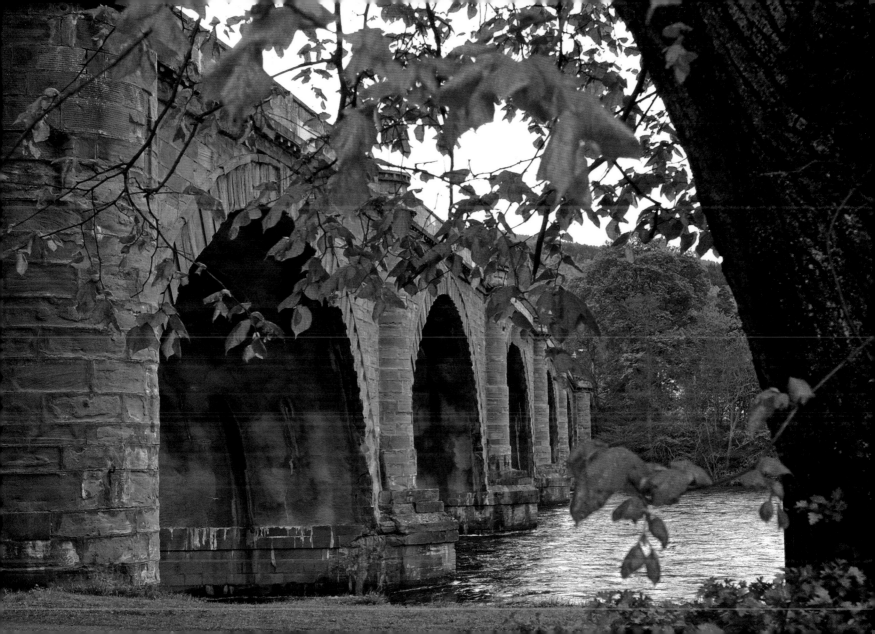

EAST COAST HARBOURS

The remains of Telford's harbour work at Dundee now forms part of the Discovery Point leisure zone (*right*).

Facing page: Gourdon is a rare example of a small harbour still working in the traditional way. Douglas Welsh has lived in the village all his life. His business includes everything from catching, curing and smoking fish to marketing.

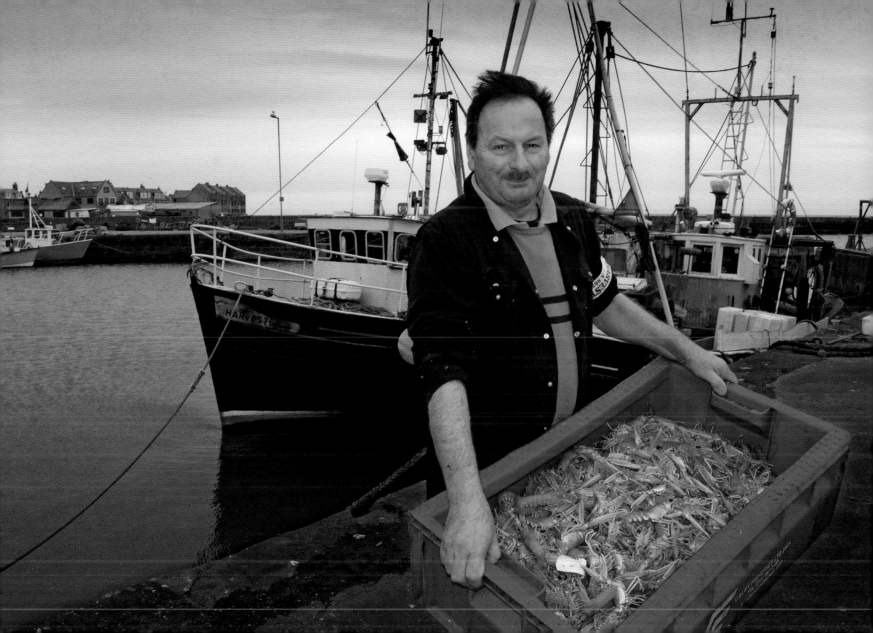

EAST COAST HARBOURS

Aberdeen already had a large
harbour, but Telford's extension
of the North Pier (seen here with
a pilot vessel bringing in an oil rig
supply ship) provided shelter to
the whole bay.

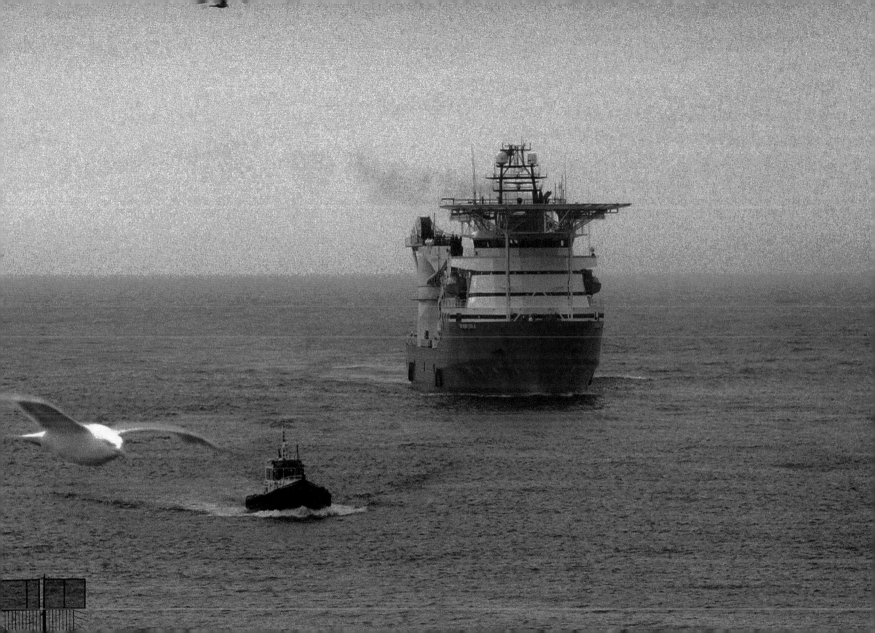

The bridges at Aberdeen over the Don (*below*), at Potarch over the Dee (*facing page*), and at Ferness over the Findhorn (*right*) are three of many associated with Telford's road-building programme.

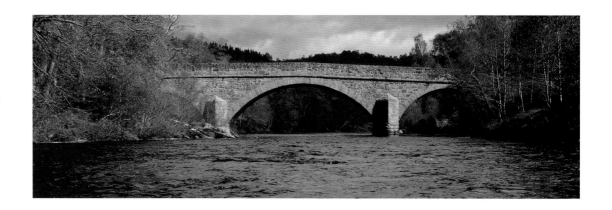

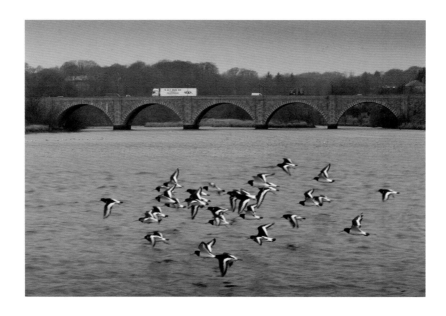

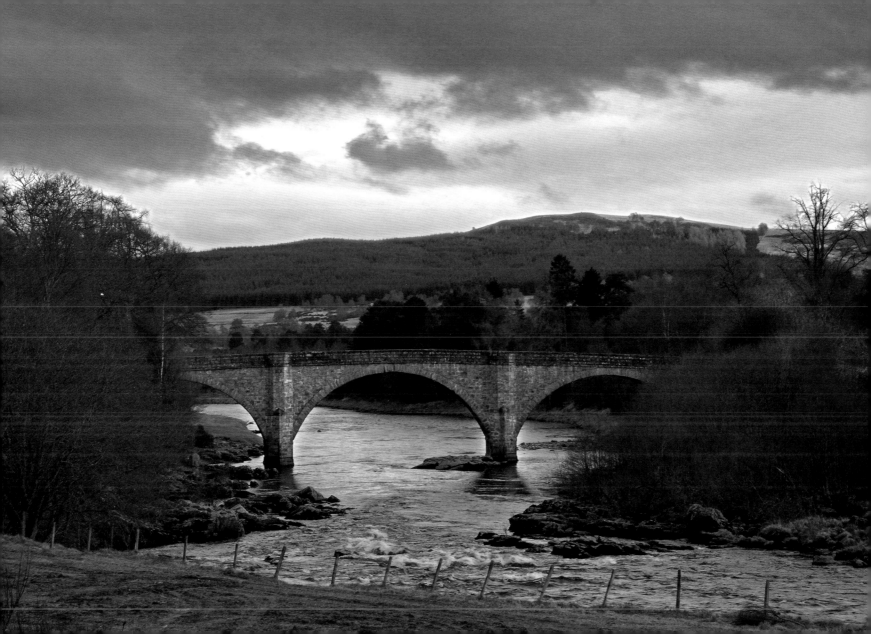

MORE EAST COAST HARBOURS

Most of Telford's improvements were simple stone-built jetties to provide mooring and shelter for small fishing boats. Cullen (*right*) is an unaltered example. Banff (*facing page*) has had more quays added.

Below: Peterhead has been hugely altered. This old lighthouse marked an original entrance.

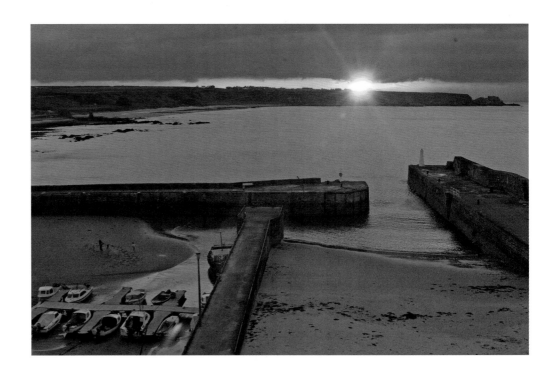

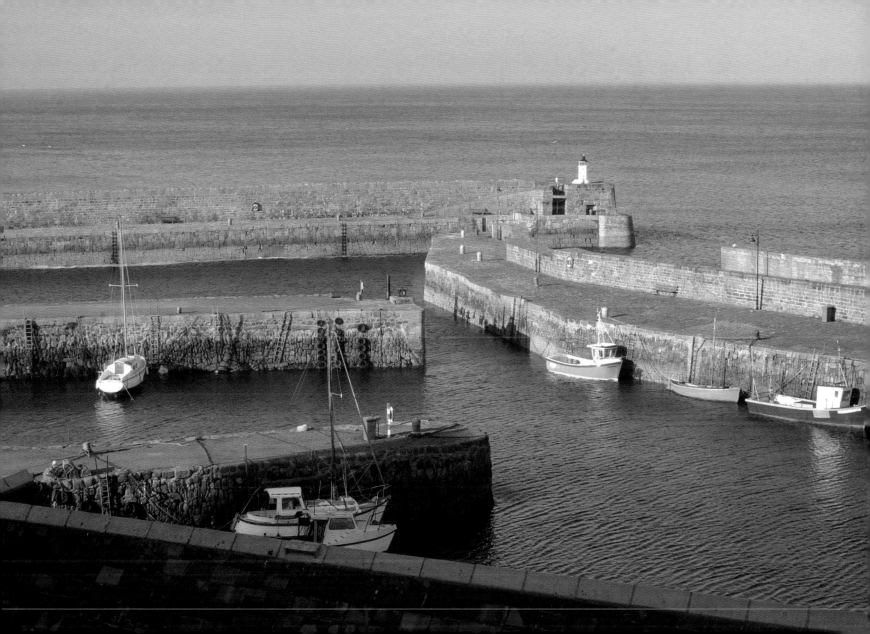

Although Telford was a skilled
mason, it was his use of iron
that made him famous. This
bridge, shining bright against its
wooded hill as it soars over the
Spey, exemplifies the lightness of
structure that must have dazzled
the world two centuries ago.

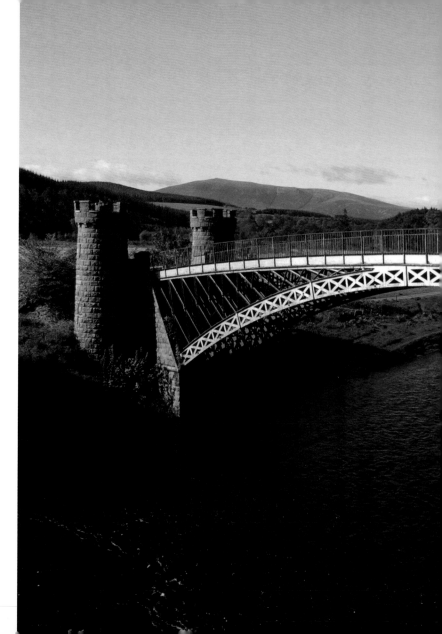

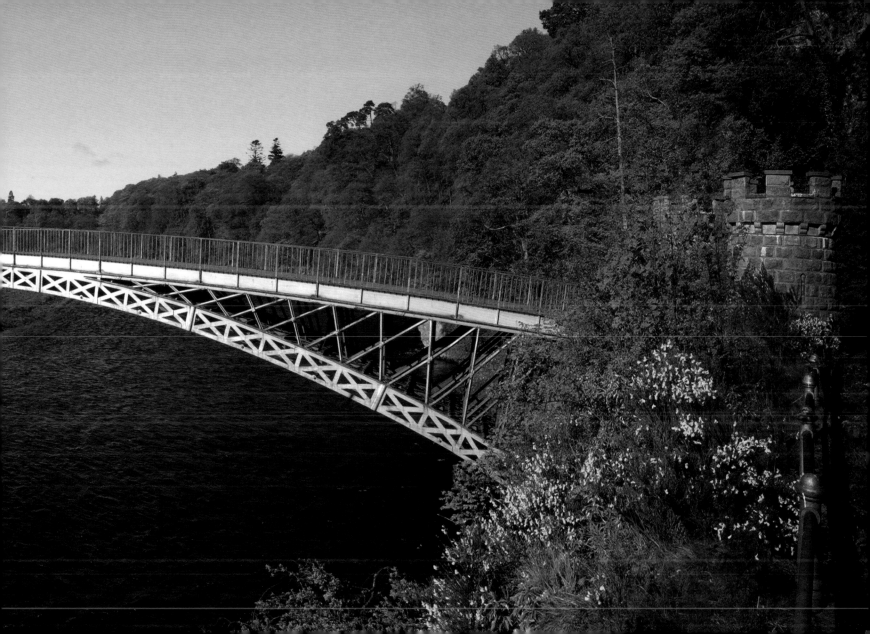

Duror (*facing page, and interior, right*) and its manse (*bottom right*) are south of the estuary on the Oban road.

Just across Corran Ferry there is a church at Ardgour (*below*), and another at Acharacle further west.

Below, centre: North of Ballahulisch at Onich, the church has vanished but the manse survives.

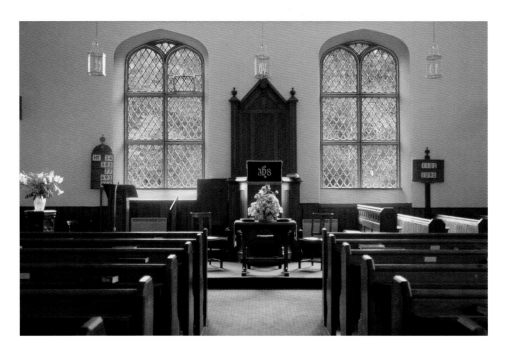

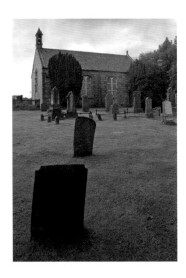

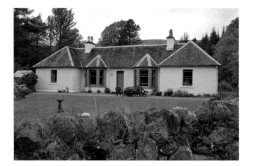

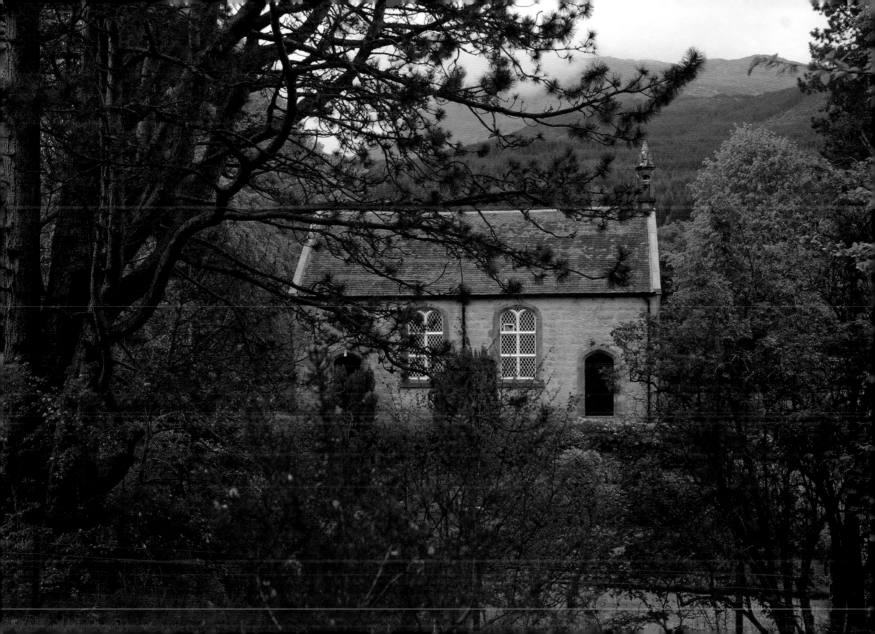

MULL

The pretty harbour town of Tobermory (*facing page*) was a 1790s new town originally planned by the British Fisheries Society. Telford became involved later, offering advice on the quality of the harbour stonework. He also advised against further cutting away of the cliff, instead recommending housing on the higher level at Breadalbane Street (*right*).

Mull boasts three rare two-storey manses: in Tobermory (*below*), at Salen (*below, centre*) and – reputedly the best – at Kinlochspelvie, where there is also a recently altered church (*below, right*).

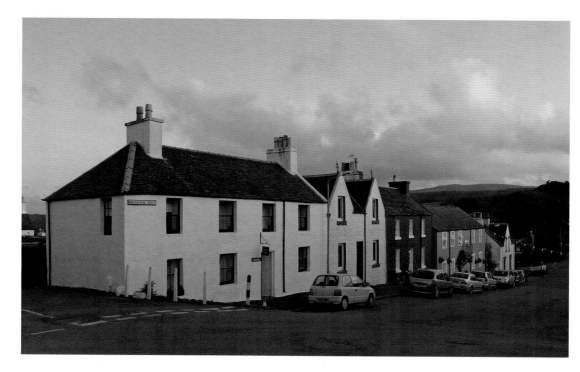

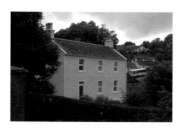

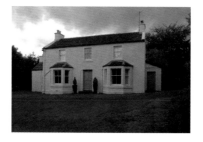

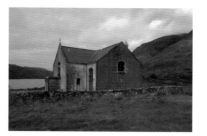

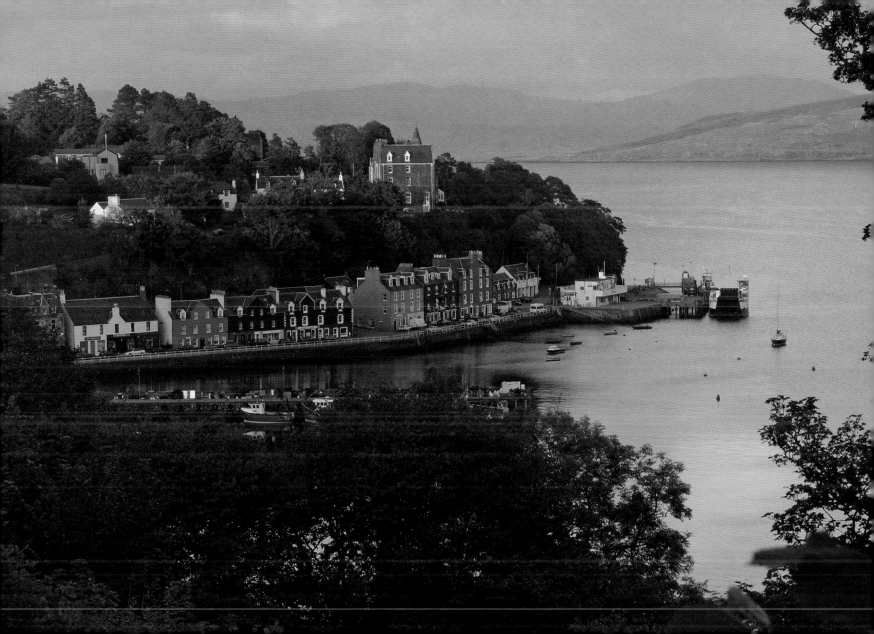

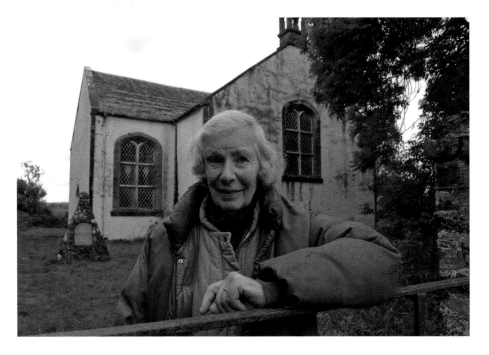

Famous for its ancient monastery and as a cradle of British Christianity, Iona has a Telford church (*facing page*) and a single-storey manse (*right*) used as a visitor centre.

Ulva, a remote island off the west coast of Mull, has a surviving church (*above*), but with no services or congregation it is hard to maintain. The Rt. Hon. Mrs J.M. Howard, who owns the church and the island, lives in the original single-storey manse close by.

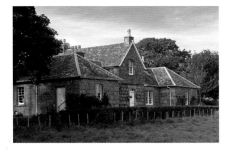

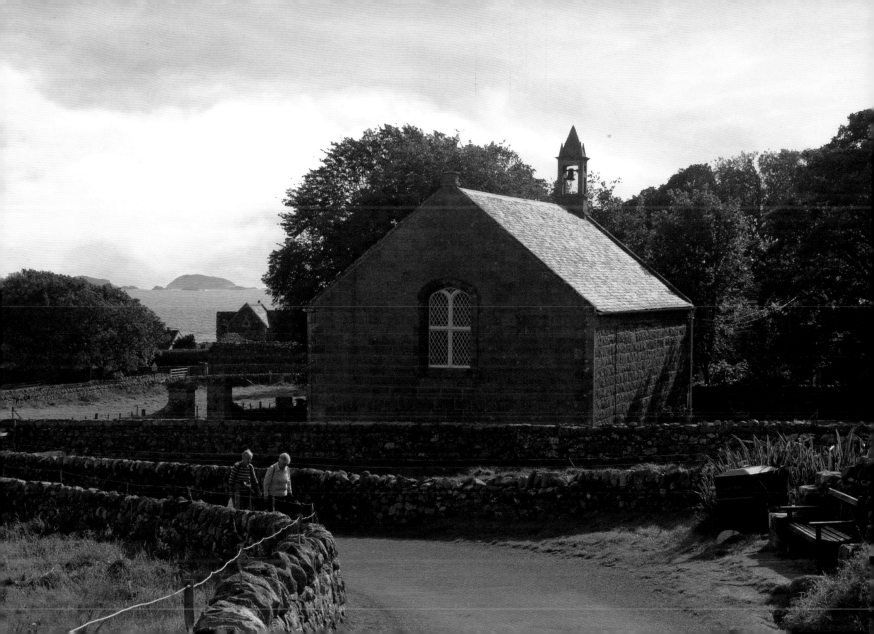

Just north of Fort William is the Caledonian Canal's most famous feature, the flight of locks at Banavie known as Neptune's Staircase.

Far right: An RNLI boat ascends the flight en route from Islay to Buckie. The white house (*below, right*) was Telford's residence during his visits.

At the top of the flight the view across the canal is towards Ben Nevis (*facing page*). The Mucomer Cut (*right*) is a channel taking surplus water away from Loch Lochy.

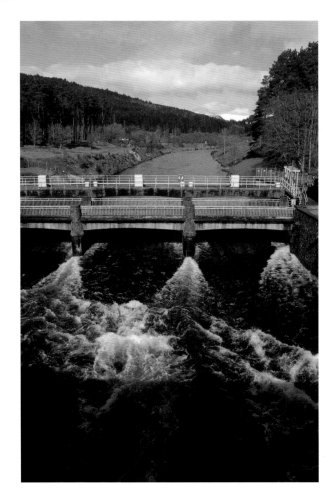

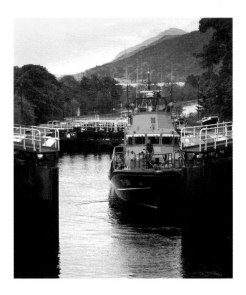

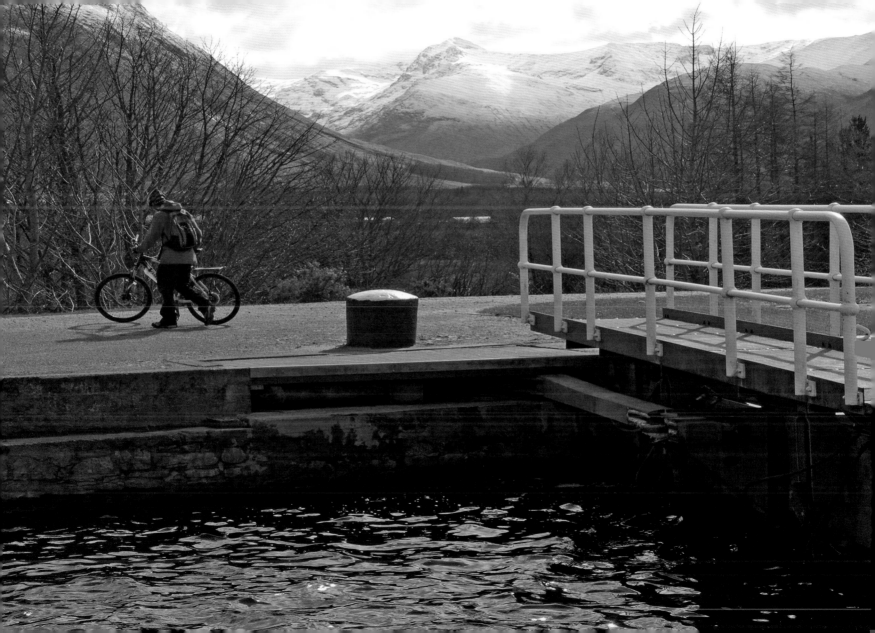

The only original swing bridge on the Caldenonian Canal is at Moy (*right and facing page*). The bridge is split, pivoting from each bank. Bridge-keeper Andrew Walker keeps the southern wing open, closing it as needed for farm traffic; when a large boat requires the whole canal width, he has to row over to open the north section.

Below: One mile west, the aqueduct at Loy with its heavy masonry tunnels for farm traffic and for the river passage underlines the lightness of Moy's iron structure.

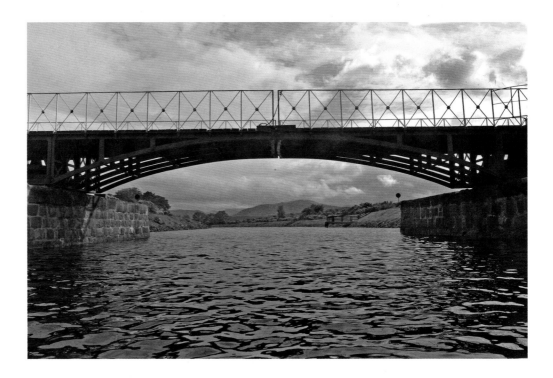

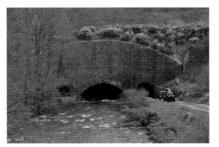

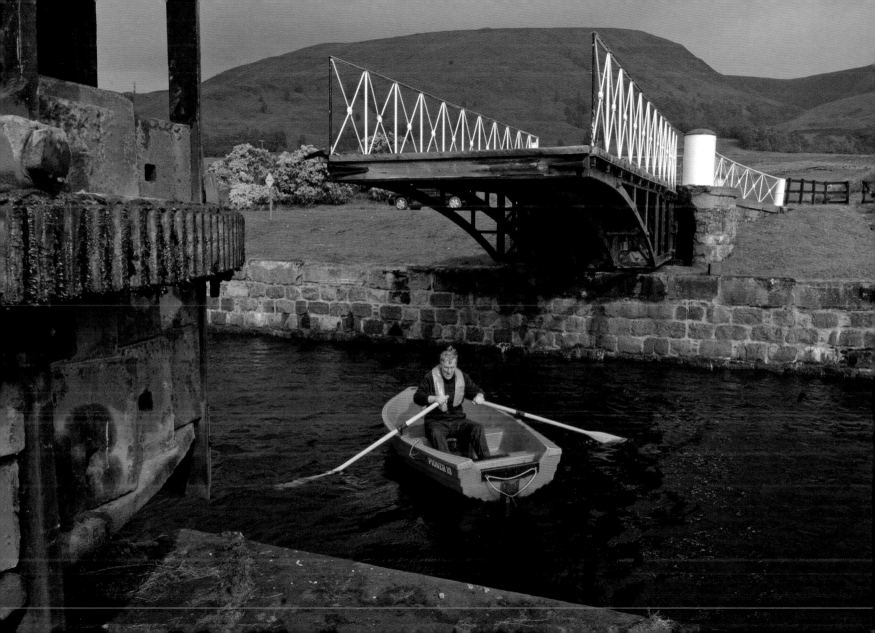

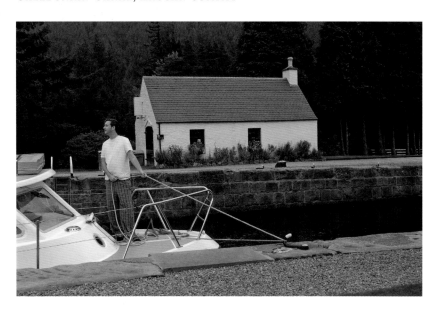

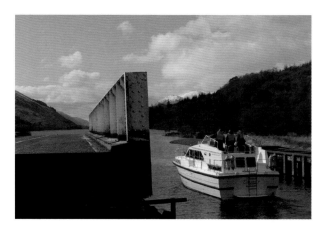

At Laggan Lock the Caledonian Canal reaches its summit level. The white building (*above*) is the original lock-keeper's house. To the north-west is the Laggan Cutting (*facing page*), its depth disguised by a plantation of Scots pines.

Beyond, the canal joins Loch Oich. This summit level – indeed, the whole canal – is supplied by water from the river Garry (*right*).

At the north end of Loch Oich, the Aberchalder swing bridge (*top right*) is the last feature before the canal reaches Fort Augustus, where a flight of locks drop into Loch Ness.

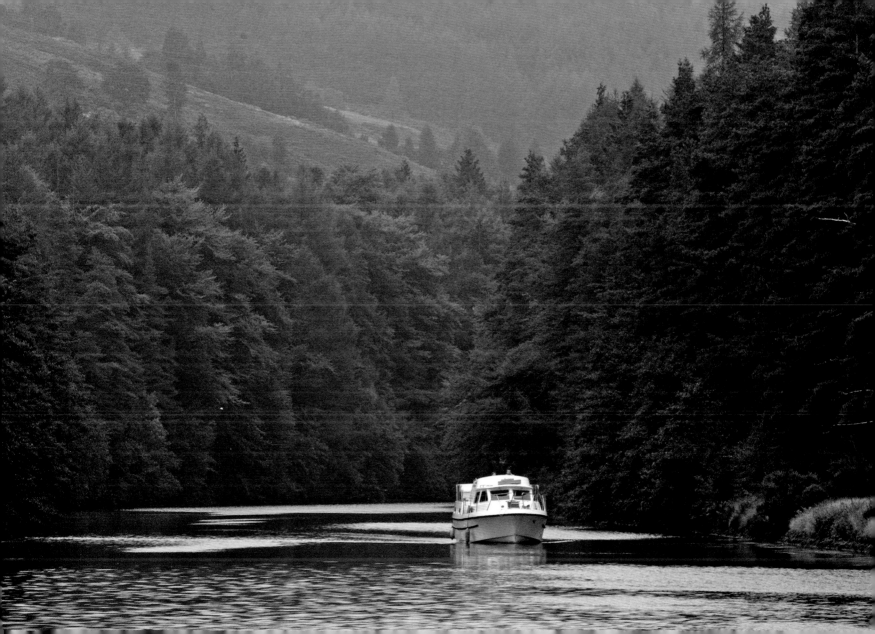

The River Ness exits the Loch at its north end over a weir (*right*), which raises the water level in Loch Ness and Loch Dochfour.

Bona lighthouse (*far right*) helps ships navigate into the canal exit. These features were kindly pointed out to the author by Mike and 'DJ' of British Waterways (*below*).

Facing page: At Clachnaharry, at the north east end of the canal, the sea lock opens out into the Beauly Firth .

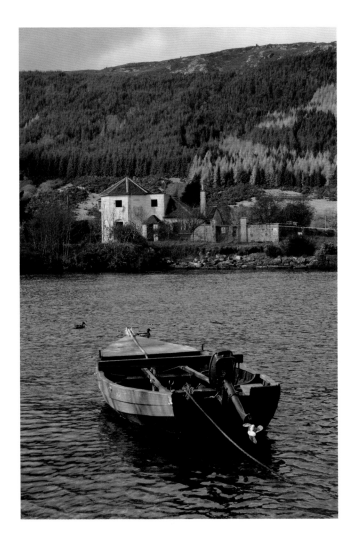

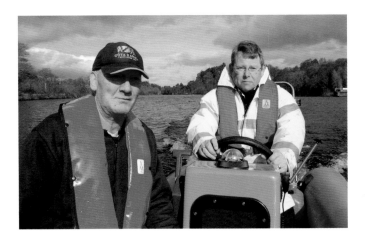

82

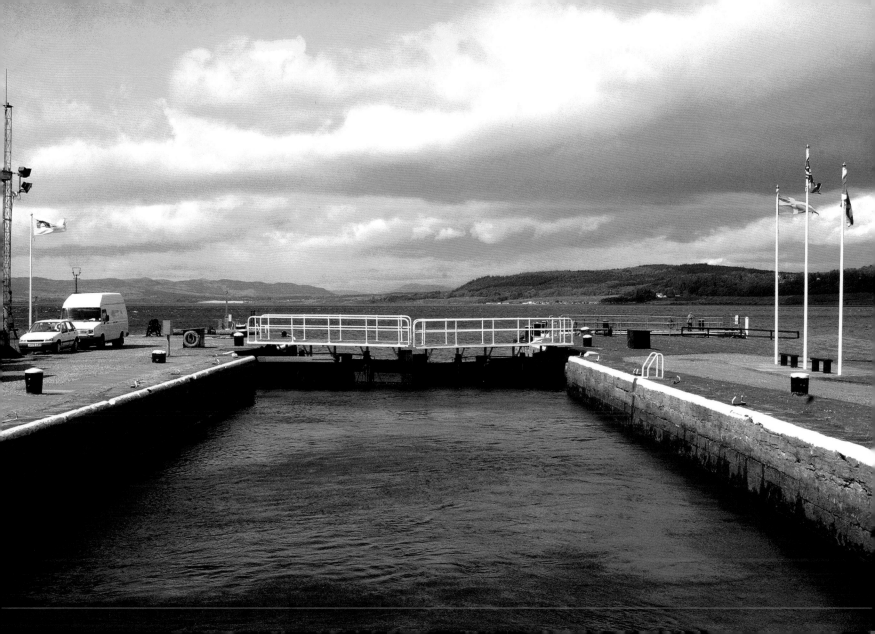

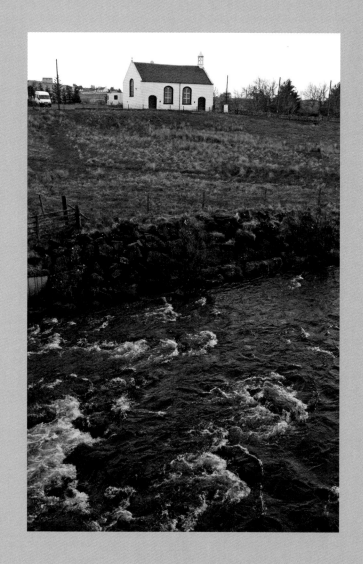

5

FAR NORTH

'Government' Churches and New Towns

Following the conclusion of the Napoleonic wars, the Westminster government, presumably grateful to God who it is supposed supports the winning side, allocated a grant to the Church of England for new building work. Almost as an afterthought, a much smaller sum was offered to the Church of Scotland, who dedicated it to building a series of outlying churches and manses in parishes either too poor to build for themselves or with such a scattered congregation that extra churches were needed.

Telford was asked to advise on this project and designed a standard plan, with a choice of one- or two-storey manse. Many of the forty-three churches, and rather fewer manses, have been altered, some are in private ownership but they still convey the pattern of the original design. Fitting in with the criteria of need inevitably all the parishes are in the Highlands and Islands; discovering these churches, often in wild and dramatic locations, makes for a rewarding tour.

If these manses and tiny churches could be seen as a distant reflection of Telford's early ambition to be an architect, further developments of the harbour projects could only amplify this contention. Both Ullapool and Tobermory grew up into much larger settlements; although they were planned before Telford's involvement, he made a serious contribution to the layout of the wide tree-lined streets that justified their description as 'New Towns'.

At Wick, on the east coast, a harbour and town already existed, but Telford took on a brief to massively extend both the residential areas and the facilities devoted to the fishing industry. His responsibility was not for individual buildings but an overall plan which integrated housing with commerce – making possible the claim that the town included the world's first industrial estate. The new development, named Pulteneytown, was indeed a new town, run independently of Wick until it was absorbed early in the twentieth century. In 1971 Wick's council took architectural advice on the future of Pulteneytown's housing: sadly the opinion was to knock it all down, though tantalising fragments remain.

While the humble nature of his work north of the border may seem of little engineering significance, the whole programme reveals a social commitment to his native country. This contention would seem validated by the fact that he took no fee from the Fisheries Society for his harbour work. Today, what high-flying architect would embrace in his schedule a set of forty low-budget village halls?

Facing page: Church at Stenscholl, north-east Skye.

As further south, simple jetties predominate, unaltered at Fortrose (*right*) and Portmahomack (*facing page*).

Invergordon (*below*) is now a huge oil rig repair yard, but sections of Telford's stone-built quays are still visible. Captain Iain Dunderdale has 'Deputy Harbour Master' on his hard hat but 'Cruise Development Manager' on his business card. Tourists call in to marvel at the rigs en route to search for Loch Ness monsters.

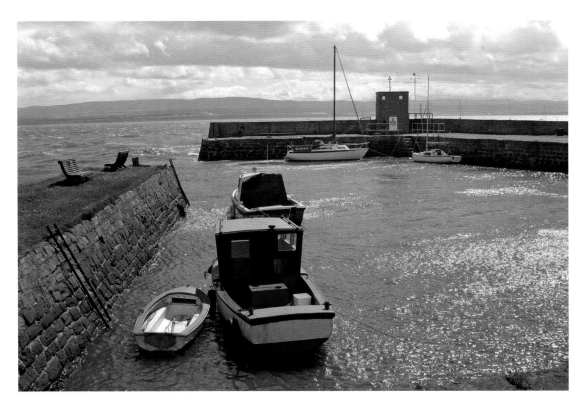

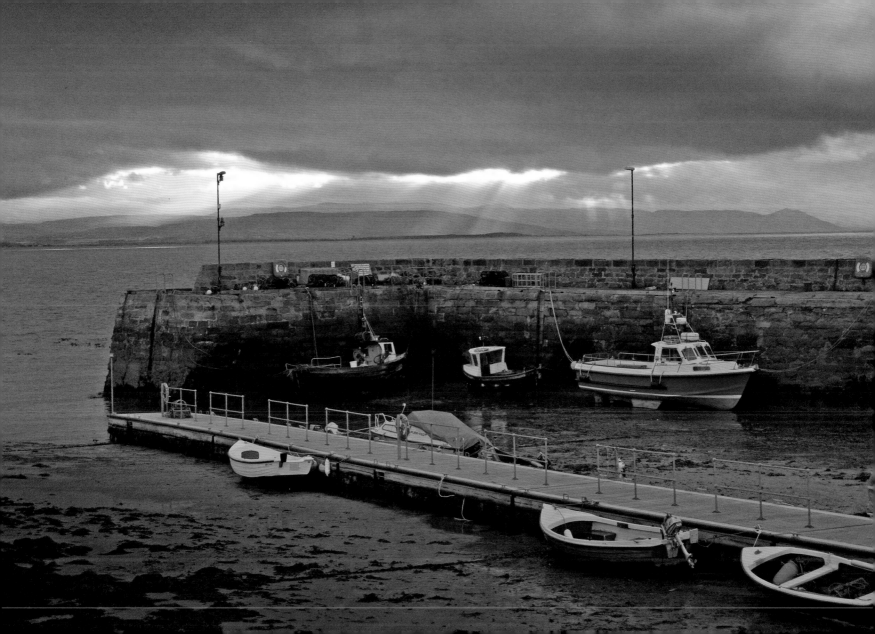

FLEET MOUND

Fleet Mound (*facing page*) is a causeway built across the Dornoch Firth, cutting twenty miles off the main road north.

The project was conceived by the Duke of Sutherland as a way of reclaiming agricultural land, and Telford was called in to help make it work. At the north end of the embankment (*right*), he installed arches allowing tidal flow, which was controlled by sluices.

Below: One of the two original controlling winches is on view at the 'History Links' museum in Dornoch.

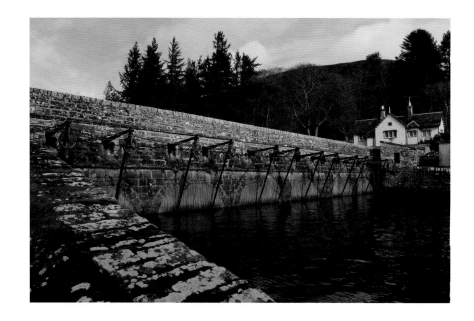

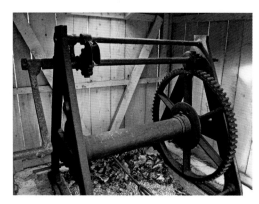

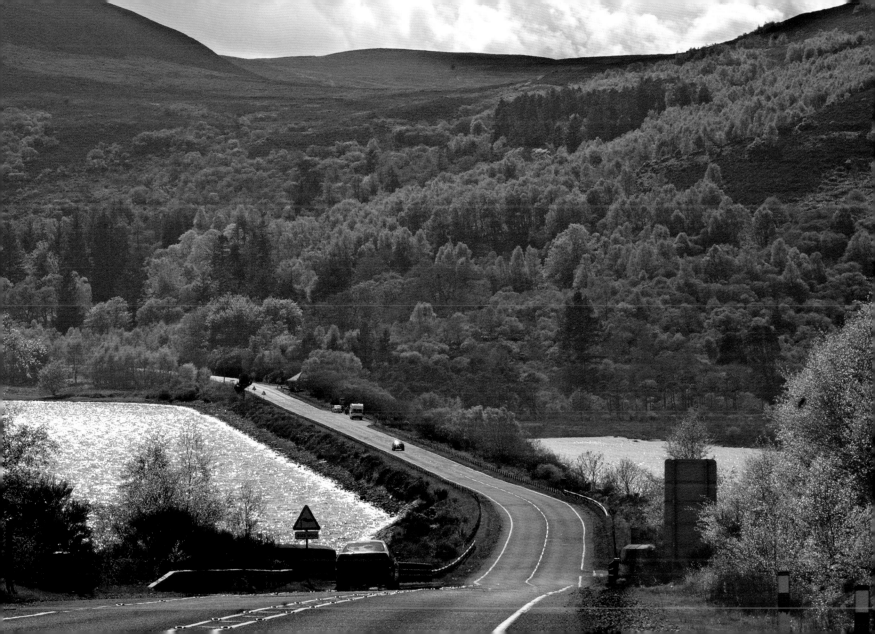

CROIK

Croik church (*right*), ten miles west of Bonar Bridge, is worth a diversion, as it bears unique witness to the mass clearances of the early nineteenth century, when tenant farmers were evicted from the land and their homes to make way for more profitable sheep-farming.

Telford's church was built in 1823 and has not been altered since. In 1845 eighteen dispossessed families, who were huddled in the churchyard, scratched desperate messages on the east window of the church (*facing page*). Some of the inscriptions read:

'Glencalvie people the wicked generation'

'Glencalvie tenants residing here'

'Glencalvie people was in the churchyard here May 24 1845'

The manse (*top right*) is the only other dwelling in this part of Glencalvie.

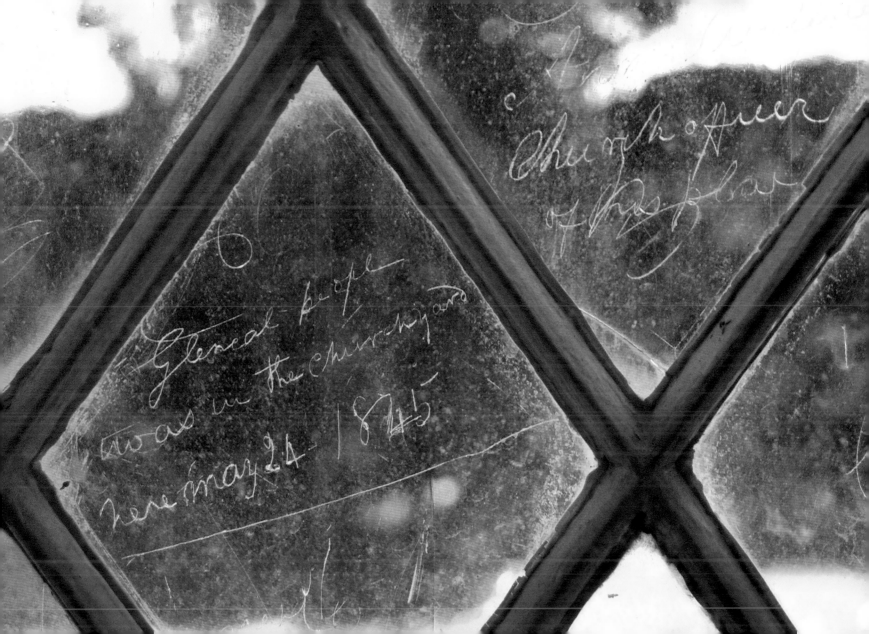

Right: Peter Wilde, assistant curator of the 'History Links' museum in Dornoch, shows a copy of a contemporary print of Bonar Bridge.

Far right: Easter Fearn, just south of Dornoch Firth.

Facing page: Fisherman at Lovat, on the Beauly river.

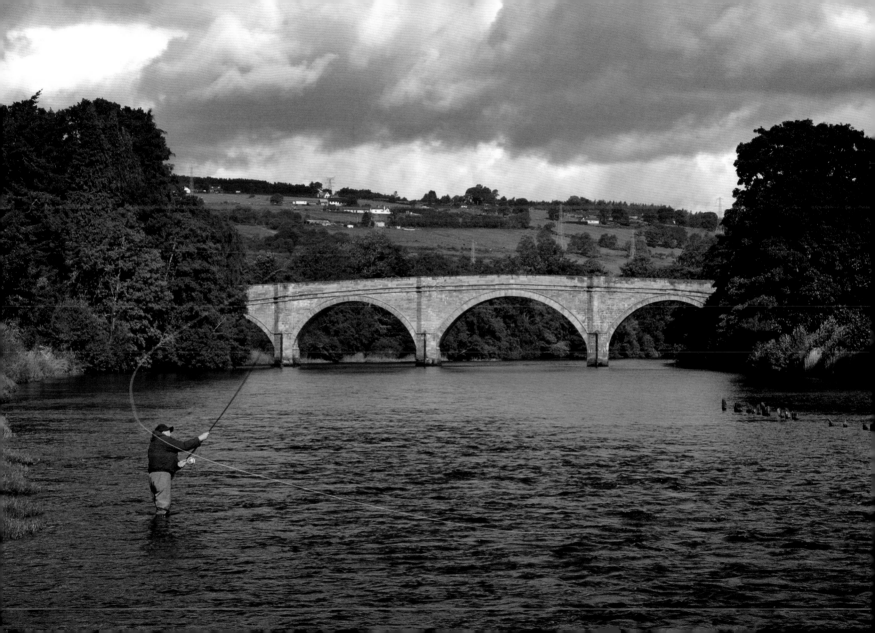

WICK

Telford built a bridge in Wick, since replaced, and a harbour, some of whose enormous stonework survives (*below right*). More importantly he planned a complete new town, named after his patron, William Pulteney.

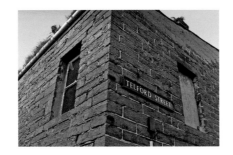

It is claimed that Pulteneytown included the world's first industrial estate; certainly the planned spaces allowed for herring-gutting and curing yards (*facing page*) as well as workshops for all the trades associated with the fishing industry. Workers' housing, conveniently close to the harbour, was part of the mix.

A heritage centre by the harbour keeps old memories alive, while projected renovations include Telford Street (*top right*).

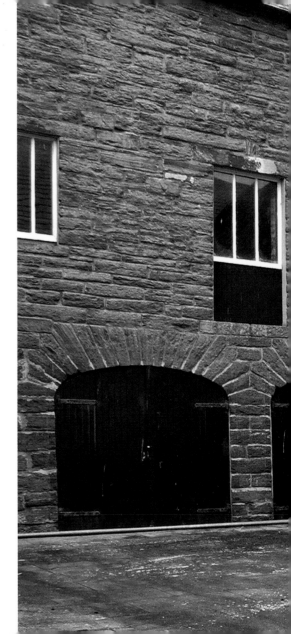

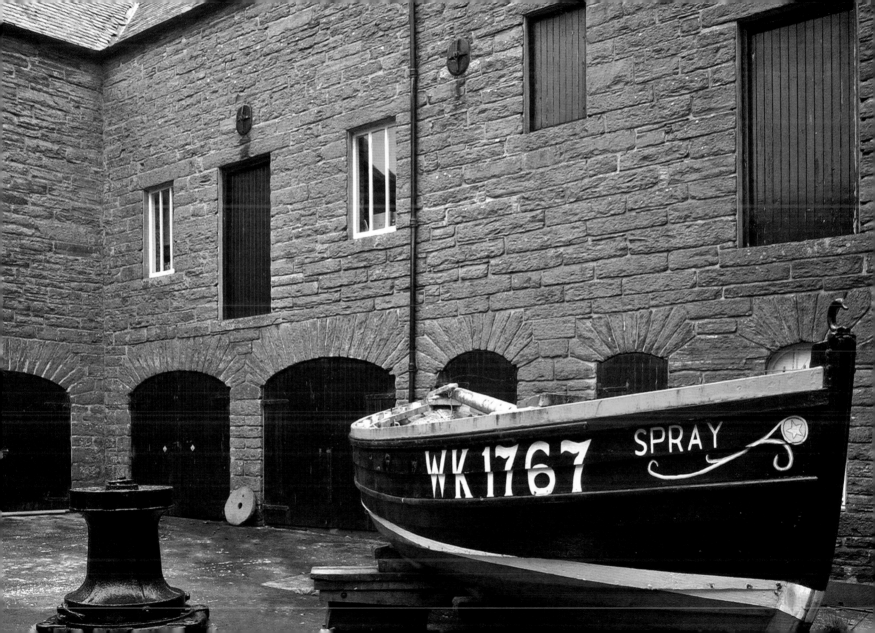

Telford's plan for Pulteneytown centred on Argyll Square, an elegant oval filled with sycamores (*facing page*). Beyond now-replaced housing were more industrial spaces, including a ropeworks (*below right*).

Pulteneytown brought prosperity to the far north, but later its luck changed and in 1903 it was incorporated into Wick. In 1940 some of the first German bombs fell on the harbour. Is this the only British town still with unrepaired war damage? In 1971 the council were advised to demolish most of the housing of Pulteneytown, but fascinating fragments remain.

Top right: Tony Sinclair, a director of the Wick heritage centre, has a story about the roundhouse (behind him in the photo). Built by Telford as a single-storey dwelling, it was bought by a Mr Bremner (a 'wreck-raiser') who found it too small. As an engineering experiment, he jacked up the whole stone-built house, roof and all, and added a new ground floor below!

FAR NORTH CHURCHES

Right: Berriedale, on a clifftop north of Helmsdale.

Below right: Keiss, north of Wick, also has a two-storey manse.

Below: Strathy, on the north coast.

Facing page: Kinlochbervie, high on the north-west tip of the Sutherland shoreline.

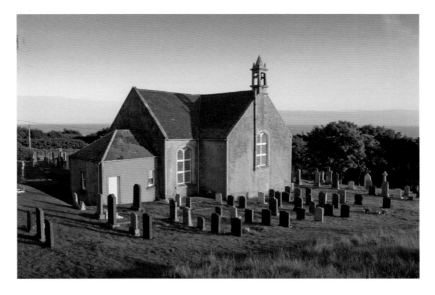

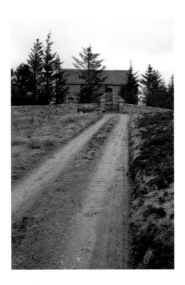

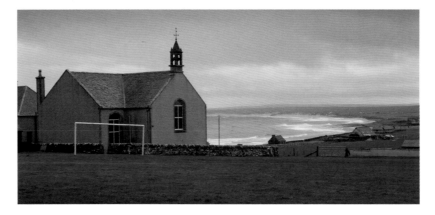

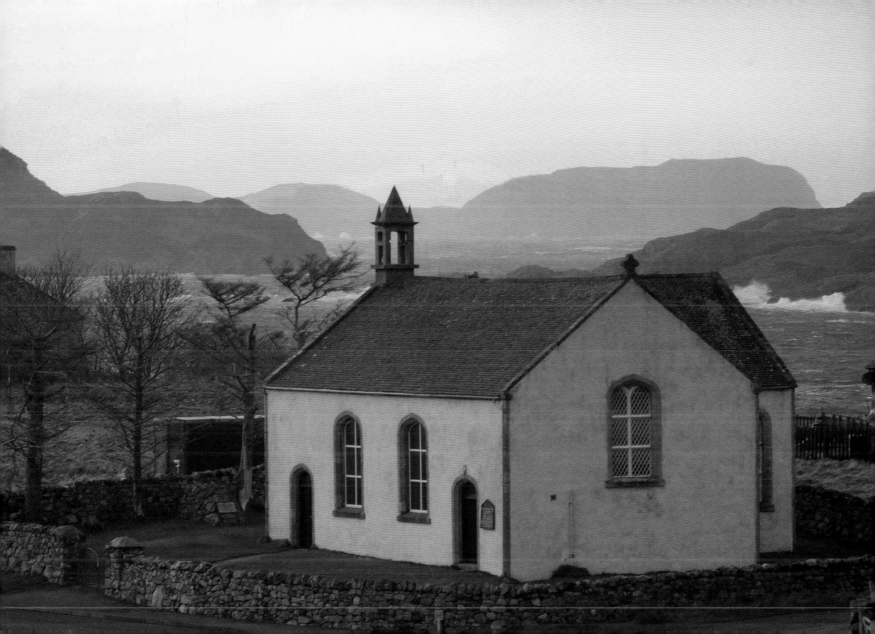

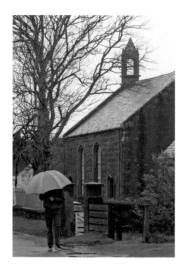

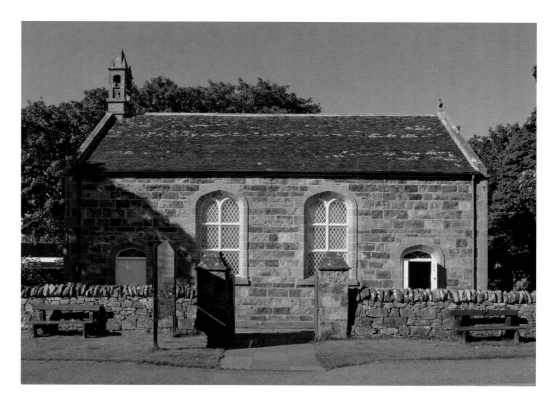

Poolewe (*above left*) is south, down the long, lollopping roads of Wester Ross.

Ullapool still has its Telford church (*above*), but his harbour work has been completely overtaken by modern developments. His suggestion to build a marketplace behind the quays was not taken up, but that is exactly where today's Saturday traders place their stalls (*facing page*). Behind the Loch Broom waterfront, Telford's advice to plan wide streets is very evident – a 'new town' style a hundred years ahead of its time.

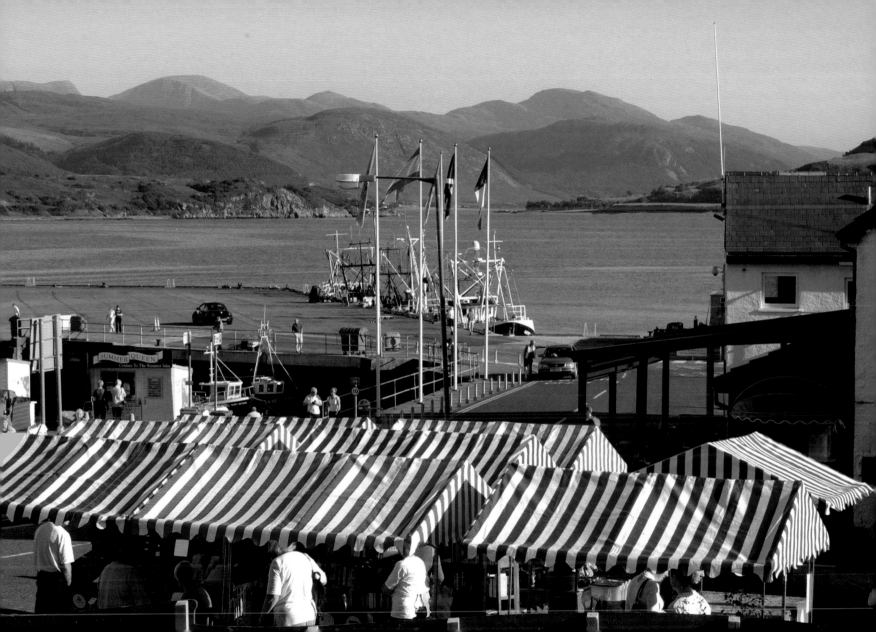

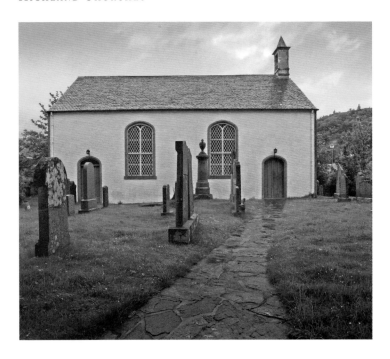

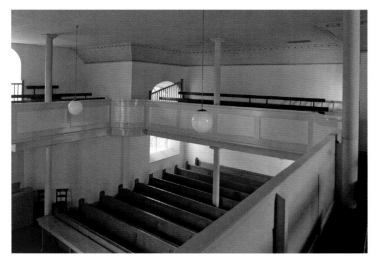

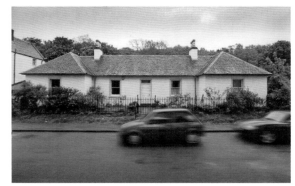

Facing page: Kinlochluikhart.

Above and top right: Plockton, north of Kyle of Lochalsh, and manse (*right*).

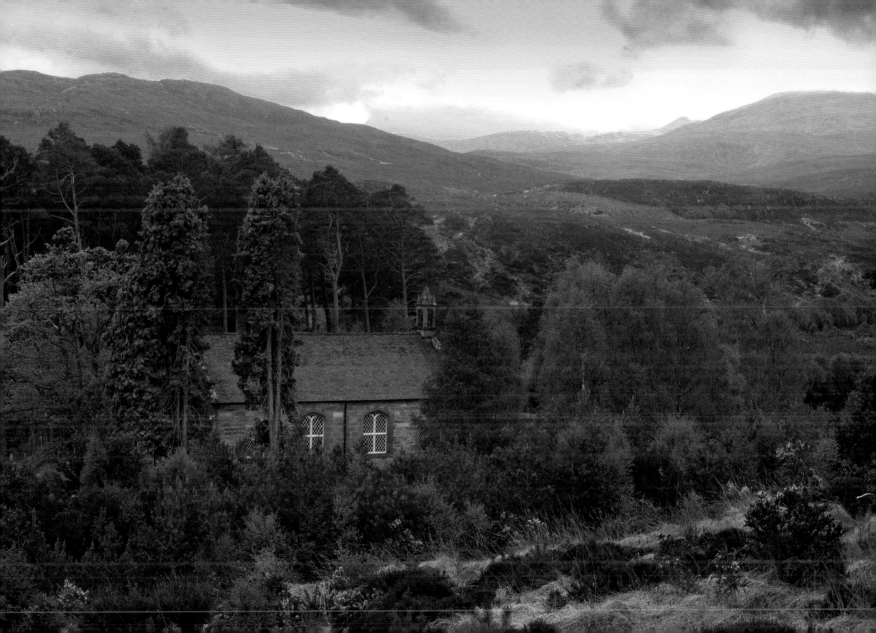

Most of the routes of Telford's
roads were so well chosen that
they lie concealed under modern
tarmac. However, on the A87 by
Loch Cluanie (*facing page*) several
sections of the original road are
visible; where they are above the
modern road, old stone block
retaining walls can be seen.

Far right: The ruins of one
of General Wade's military
roads (built following the 1745
rebellion) leading into a Telford
section, with the modern road
beyond.

Shiel Bridge (*right*) is also on
this route.

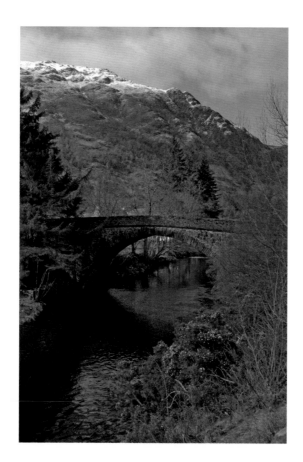

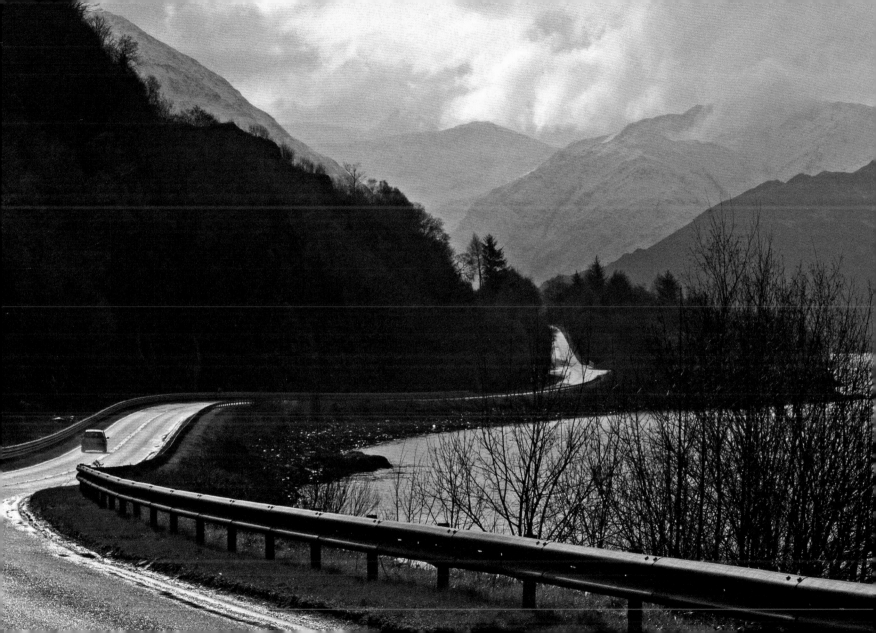

Facing page: Telford's church and manse stand together under a mountain at Stenscholl on the north-east of Skye.

Right: To the west, on another northern peninsula, Hallin has a church, now disused, with a manse nextdoor (*below*).

Within a mile of Hallin, on the western shoreline, Telford planned a new settlement for the Fisheries Society. Known as Lochbay, the scheme never came to fruition, but some cottages in the hamlet of Stein date from that time.

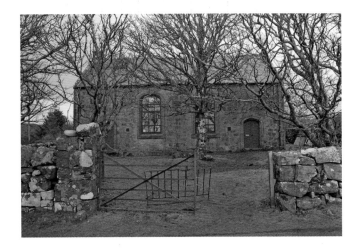

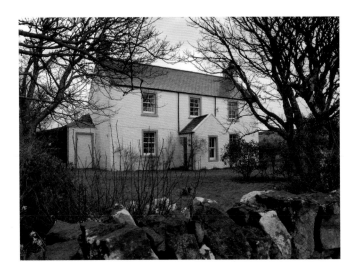

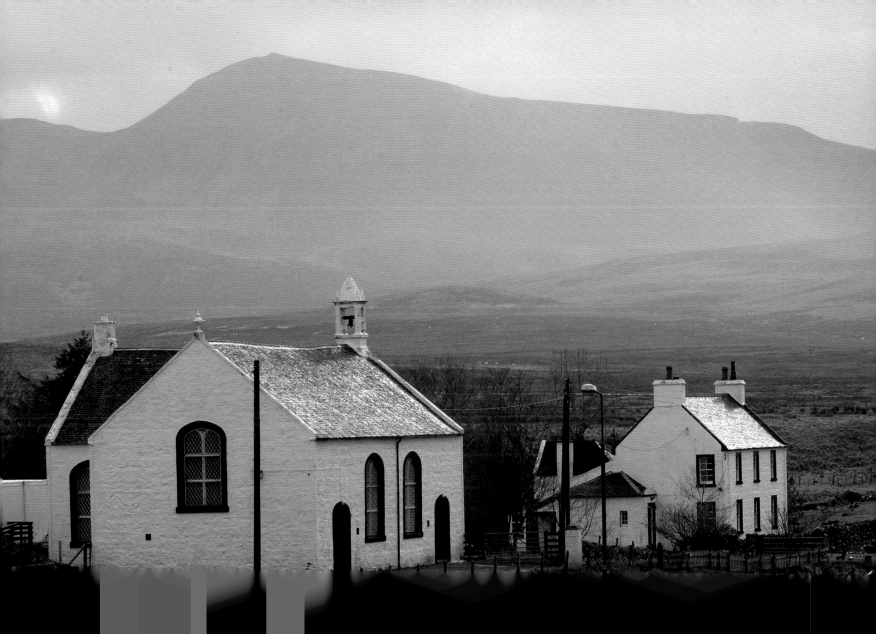

6

THE HOLYHEAD ROAD

At the beginning of the nineteenth century Britain's roads were, in general, in a worse state than the Romans had left them. Even the most important routes were the responsibility of individual parishes or separate turnpike trusts. There was little incentive for maintenance or improvements.

The main Holyhead road, important as the route to Ireland, was no exception. Particularly to the west of Shrewsbury it was often no more than a cart-track, and on Anglesey was said to be a mere grassy path. A new government initiative overruled the accepted proposition that each trust would be responsible for its own little section; in 1810 Telford was commissioned to report on the state of the whole route from London to Holyhead, and in 1815 funds were voted for him to build a modern coach road of consistent standard throughout.

This enterprise produced some of his most inventive work. Even as the new road left London he stamped out one of his enduring principles: that a steep grade cannot be tolerated on a modern road. Archway cutting (the iron bridge that gave it this name came later) bypasses the steep climb to Highgate. He even managed to keep to this policy as the route ran through Snowdonia: although a new turnpike road had been attempted two decades earlier, Telford's skilfully graded Nant Ffrancon pass must have seemed at the time nothing short of a miracle (especially to the horses).

It was on the Welsh sections of the road that his bridge-building again did him proud. Crossing the Menai Straits – a rough and sometimes impossible boat passage – was the biggest challenge. Telford came up with something radically new: a giant suspension bridge with a main span of nearly six hundred feet, soaring a hundred feet above the sea. As at Pontcysyllte two decades earlier, many thought the plan impossible. That he could implement it must, again, be due in some measure to his association with William Hazeldine the iron founder, who was by then producing wrought iron from his forge at Upton Magna. It is the properties of wrought iron that gave the suspension chains their strength.

Conwy has a similar bridge, built in miniature, and it is tempting to think it a model for Menai, but in fact the larger bridge was put in hand first. At Bettws-y-coed the cast-iron bridge over the Conwy river was not a technical breakthrough but a visual one: cast into the outer arches are the words 'Built in the year the Battle of Waterloo was fought'. North Wales is indeed a treasure trove for Telford's ironwork.

Facing page: The Holyhead road towards Snowdonia.

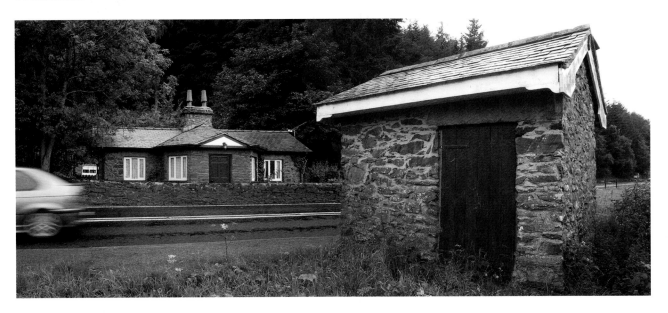

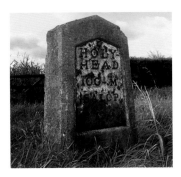

The toll house at Montford Bridge is one of the few features remaining on the English sections of the road (*facing page*). The milestone (*left*) is a mile west on the A5 road.

Above: Ty Isaf, into Wales past Llangollen, has the distinction of its weigh house as well as toll house remaining.

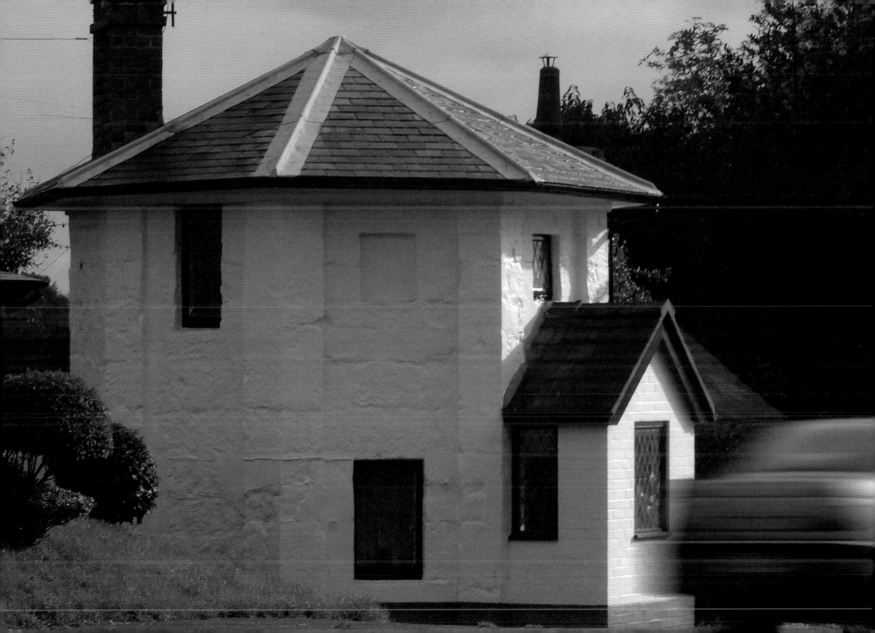

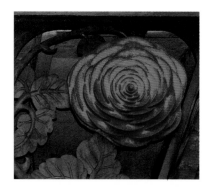

At Waterloo Bridge Telford
showed a rare moment of
flamboyance: cast into the
outer ribs of this iron bridge,
built in Wales by a Scot for the
English road to Ireland, are the
emblems of leek, thistle, rose
and shamrock. A shame so many
travellers on the A5 speed across
and never see them!

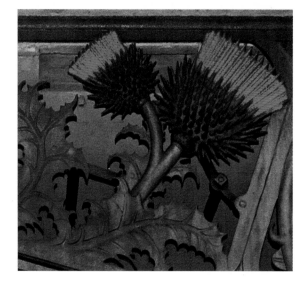

1815

THIS.ARCH.WAS.CONSTRUCTED.IN.THE.SAME.YEAR.THE.BATTLE.OF.WATERLOO.WAS.FOUGHT

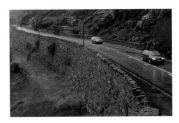

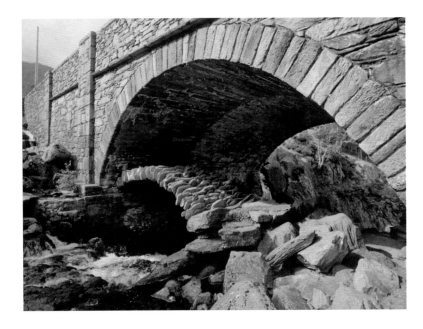

Past Lake Ogwen, the Nant Ffrancon pass, Telford's road clings to the hill above a huge retaining wall, keeping the gradient at a maximum of 1:22 (*above*). To the left of the wall can be seen the grassy remains of a turnpike road – an attempt to improve the route some two decades earlier.

Above right: Pont Pen-y-benglog crosses Afon Ogwen just below the summit of the pass. Telford's arch has been extended to widen the road, so bridging the remains of the older turnpike structure.

Stone-walled 'depots' (*right*), for storing road-stone for repairs, were built regularly throughout the final sections of the road (this example is on Anglesey).

Facing page: Into the mountains after Capel Curig the milestones become regular features (MS37 seen here has Tryfan in the background).

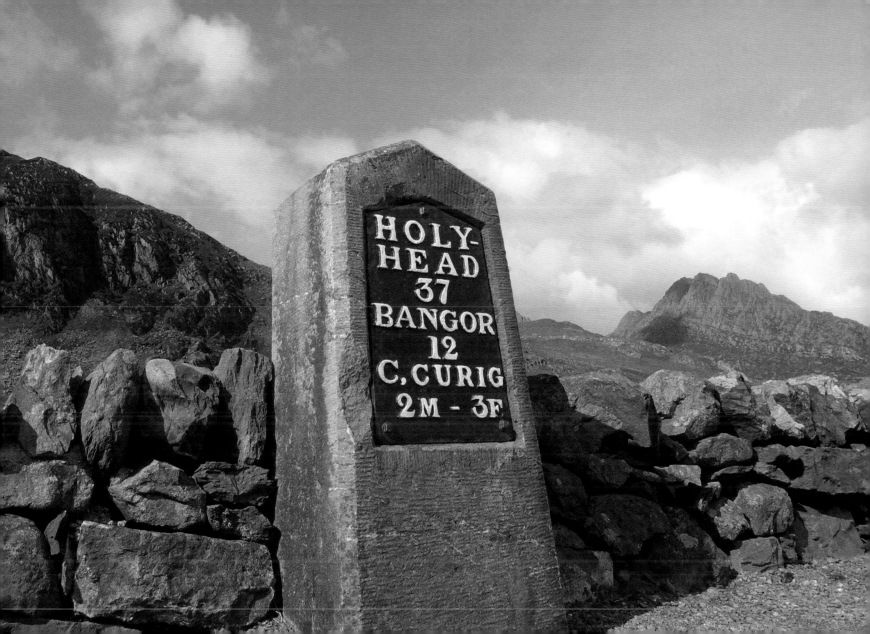

HOLY-
HEAD
37
BANGOR
12
C. CURIG
2M - 3F

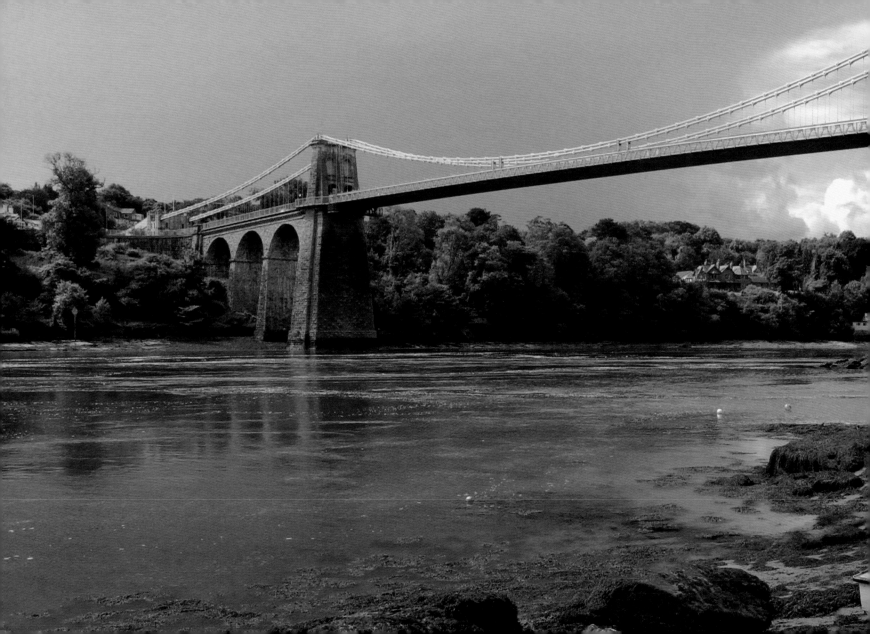

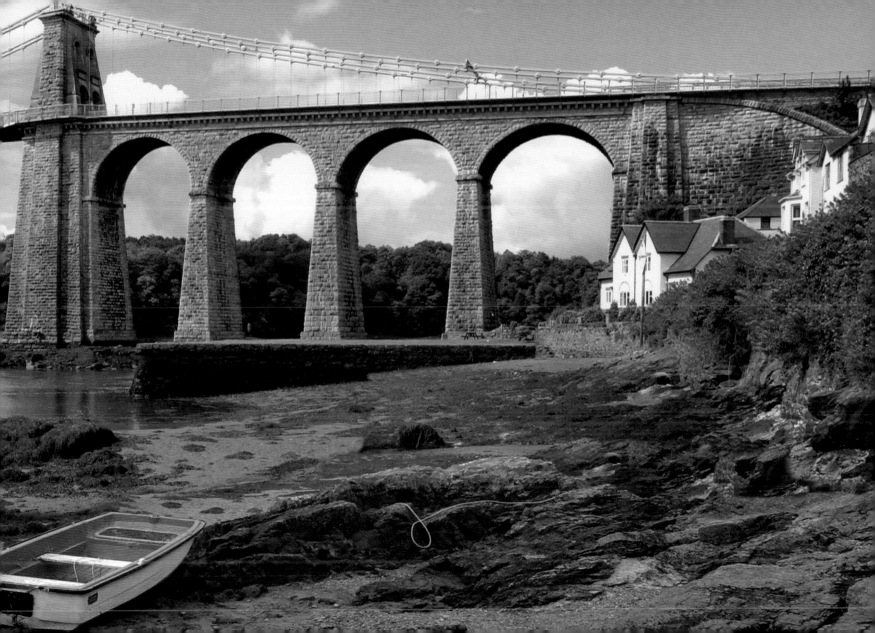

Previous page: Panoramic view of the Menai Bridge from Beech road, Anglesey.

The Menai Bridge was another wonder of the age, although the original chains have been modified to cope with today's traffic. Seeing the bridge from a boat in rough weather (*facing page*) underlines what a hazardous stretch of water the Straits can be. Waiting for the sun can take a long time in North Wales, and Telford certainly was not deterred by a few raindrops.

The 'sunrise' gate (*above*), by the south side anchoring tower, is typical of those used at tolls along the road.

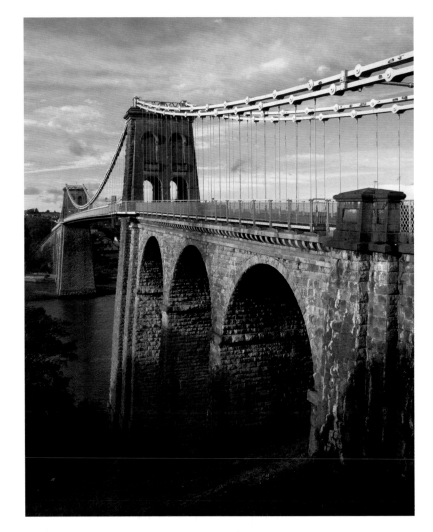

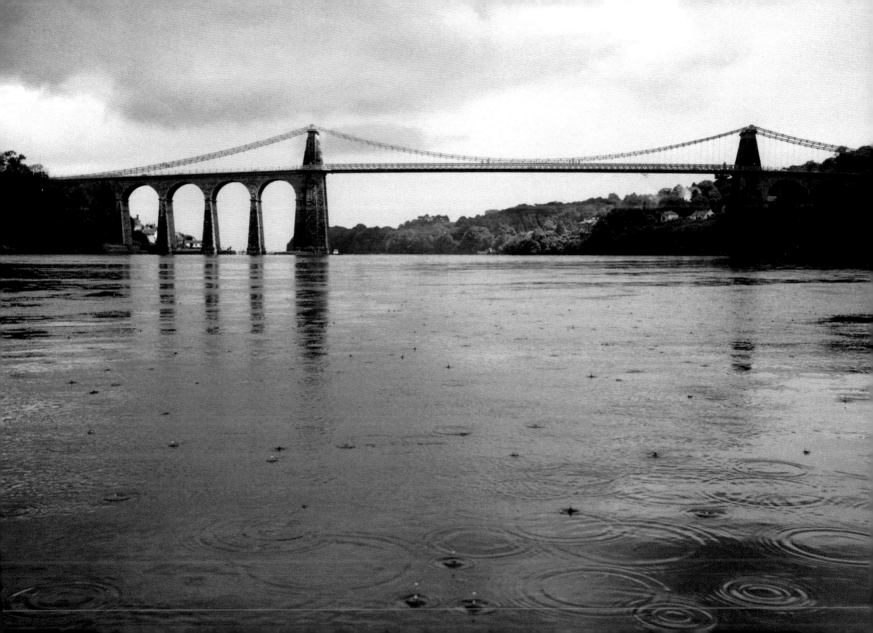

Right: The tollhouse at Llanfair PG is arguably the best preserved example on the Holyhead road, and is complete with its original tariff (*below*).

Facing page: The Stanley Embankment, just before Holyhead, took the road straight through a coastal swamp which previous routes had not even attempted. The sluice allows tidal flow, as well as white-water canoe practice. Telford's line is now bypassed by a parallel road, from which this picture was taken.

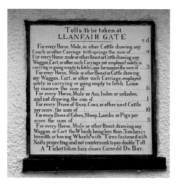

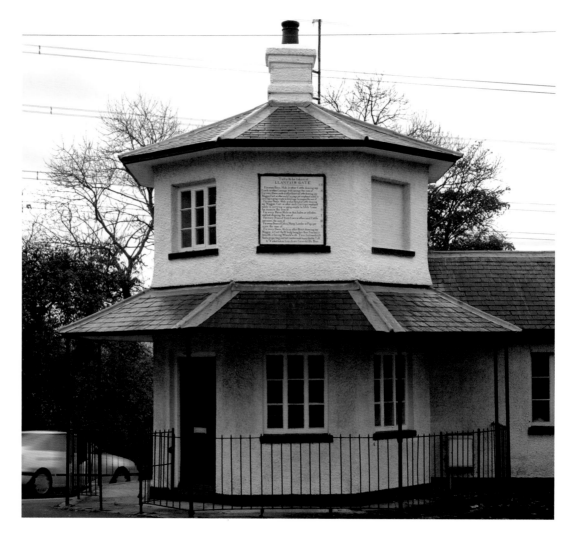

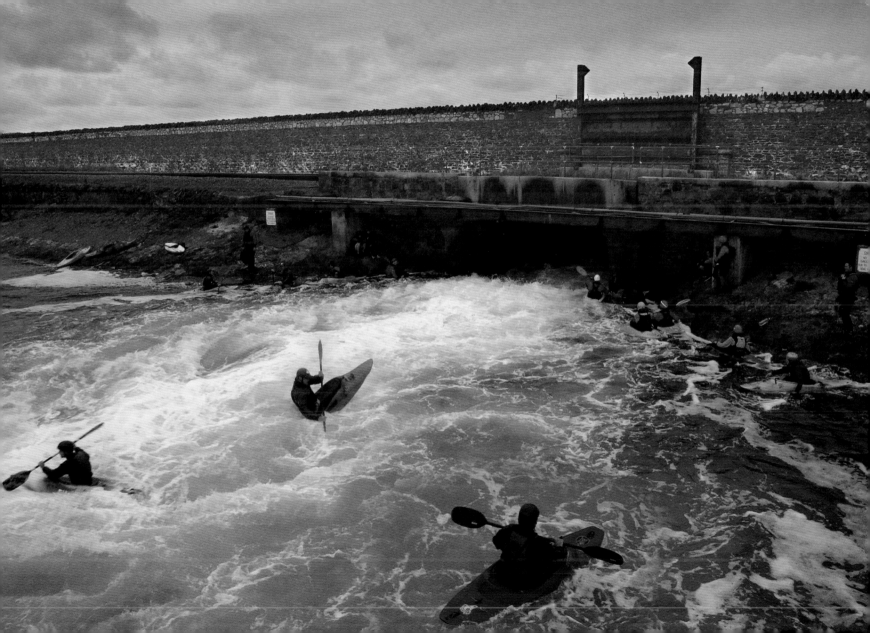

CONWY

This delicate suspension bridge was not a model for Menai, but built after it. Castellated towers stand in sympathy with the castle beyond.

Here the 'sunrise' tollgate is matched by a pedestrian version (*right*). The detail (*below*) shows the iron bolts, part of the original suspension chains.

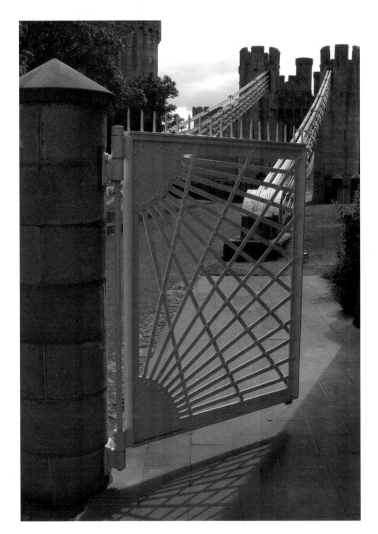

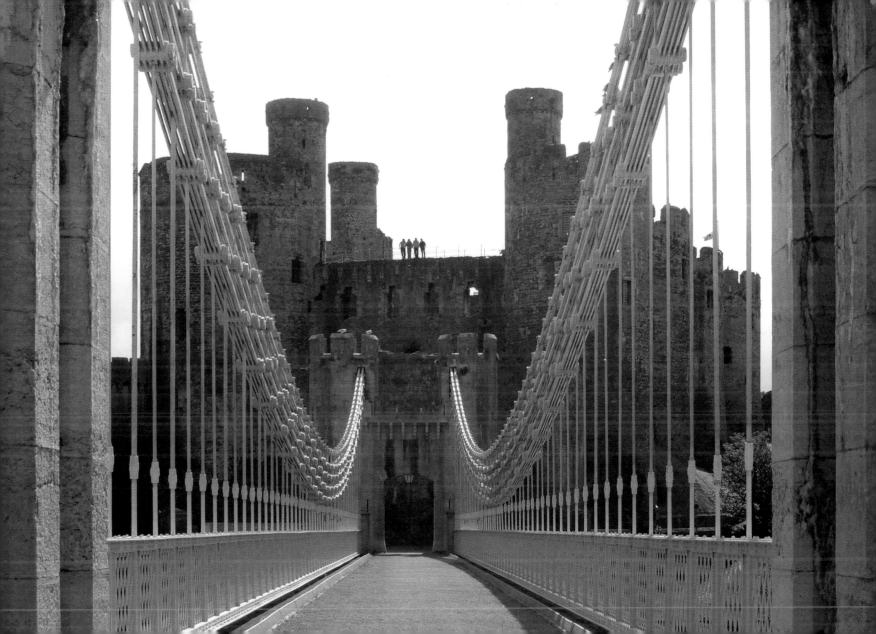

7

Canals: Towards the Age of Railways

Chester Canal

Beeston lock on the Chester canal, the vital link between the Ellesmere's two sections, had been built on quicksand and constantly leaked: Telford solved the problem by lining the insides of the masonry with iron plates, a technique he had employed on the Chirk aqueduct.

Harecastle Tunnel, on the Trent and Mersey

By 1815, Harecastle Hill tunnel, on the important Trent and Mersey canal, had become a bottleneck. More than a mile long, when Brindley built it half a century earlier it was considered an engineering masterpiece. But there was no towpath (boatman 'legged it' through, lying on their backs and pushing against the roof); worse, it was narrow and provided only one-way traffic with queues of boats incurring costly delays.

Rennie had been commissioned to drive a second tunnel; when he died in 1822 Telford took over his scheme. This was to include a towpath, though the canal was still not wide enough for boats to pass, the plan being to run one-way traffic in conjunction with the existing tunnel. When it opened in 1827 it had taken less than two years to build, compared with Brindley's original which had taken nine.

Birmingham Canal improvements

While the navvies were still at work under Harecastle Hill, Telford was asked to advise on improving the canal west of Birmingham. His proposals represented nothing short of a revolutionary approach to canal design.

Canals had grown up with the concept that they should follow the contour lines, winding their way laboriously and at length to achieve their

Facing page: Narrow lock and bypass on the Ellesmere canal.

destination. Attempts to create more direct routes had been burdened by all the extra locks needed to go up and down the hills – the extra construction cost, a slowing down of traffic and additional needs for water supply to the top levels.

Utilising cuttings of previously undreamt of dimensions, Telford determined that the new Birmingham canal would be both straight and level. If Brindley's canals could be likened to country lanes, Telford's new concept was a motorway.

Birmingham and Liverpool Junction

By the late 1820s the railways were being seen by the canal companies as a potential threat to their traffic. In response to a proposal for a Birmingham and Liverpool railway, the Birmingham Canal company asked Telford to survey a similar route for a new canal. This was apparently enough for the railway company to withdraw, and the main opposition to the new scheme came from the jealousies of the Trent and Mersey who, like Telford himself, didn't accept that the railways were the real threat.

Telford's line for the new Birmingham and Liverpool (today part of the Shropshire Union) adopted the philosophy of his newly finished work in Birmingham – straight, wide and level. There were new problems to surmount, caused largely by the intransigence of two landowners forcing the canal onto lower ground (to avoid a deer park and a pheasant wood). The embankments needed, at Shelmore and Nantwich, to cope with what must have initially seemed minor annoyances, proved unstable, and slippage caused literally years of frustration; the new canal eventually opened in 1837, two years after Telford's death.

Beeston lock on the Chester canal (*facing page*) had been built on quicksand and constantly leaked. Telford solved the problem by lining the insides of the masonry with iron plates, a technique he had employed on the Chirk aqueduct.

Standedge Tunnel, over three miles long under the Pennines on the Huddersfield Narrow Canal, had a construction problem. Working from both ends, it was discovered that the two sections would fail to meet in the middle! Telford was drafted in and managed to minimise the inevitable 'S' bend at the meeting point. The photograph (*right*) shows the east portal at Marsden.

Facing page: At Telford's Harecastle Hill tunnel northern exit (with Brindley's original to its right), the redness of the water is due to seepage from iron workings inside the hill. The towpath is today out of use, as deep in the tunnel the whole canal has sunk – the suspended white-painted iron chains (*below*) indicate available roof clearance inside. One-way traffic is supervised by British Waterways 'helmsman' Mel Bryan, seen here inspecting the tunnel roof.

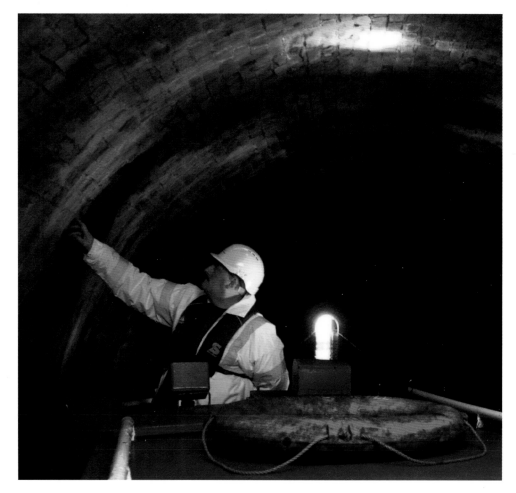

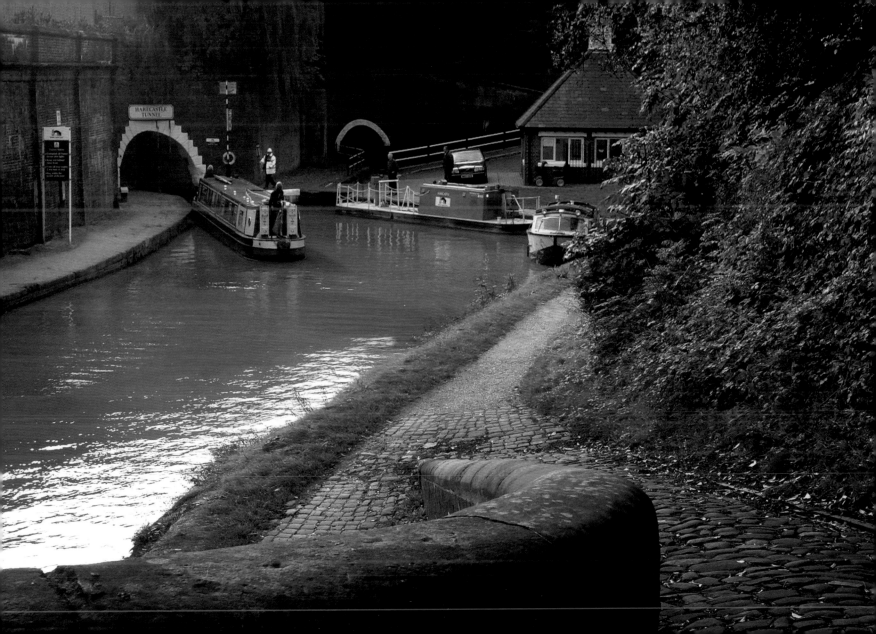

At the junction of the old and
new levels west of Birmingham
(*right*), the right branch connects
through locks to the old system,
while Telford's new low line goes
straight ahead, passing under
Galton Bridge (*facing page*) as it
enters the Smethwick cutting.
Cast iron is by Horsley (*below*).

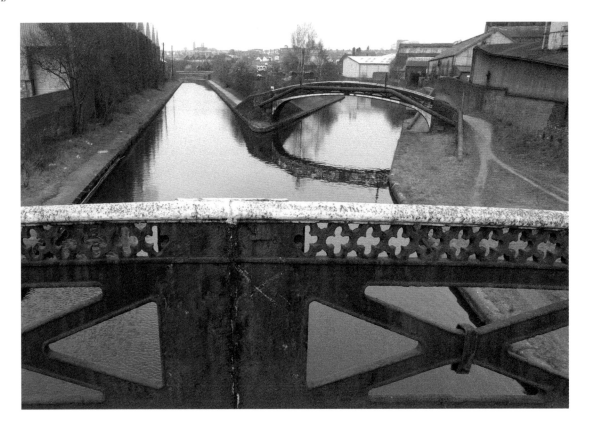

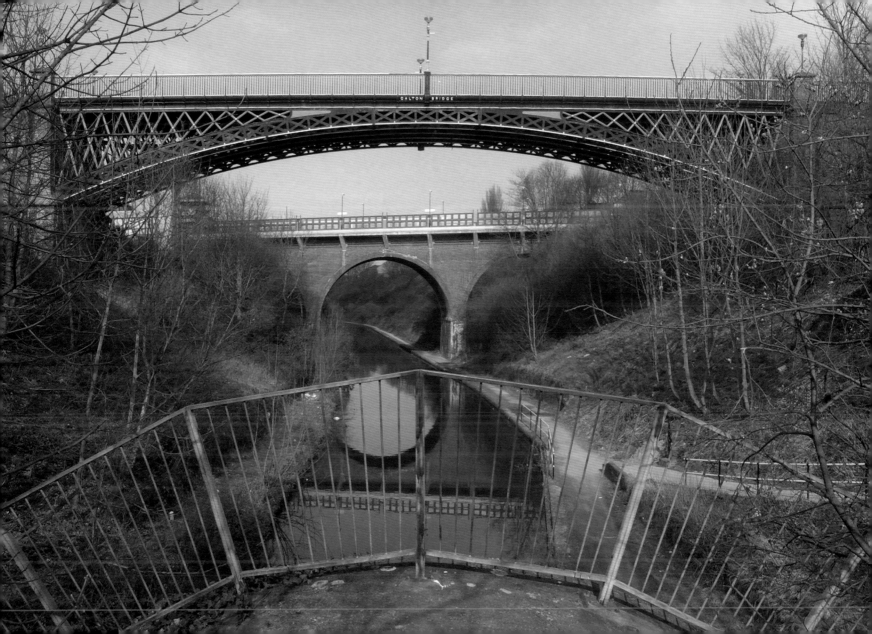

BIRMINGHAM, ENGINE ARM

Rotton Park Reservoir (pump house and control gear, *right* and *below*) provides the water for old and new levels. The canal-sized supply passes industrial wharves, then crosses Telford's new line on the Engine Arm Aqueduct (*facing page*) before dropping through locks to the lower level.

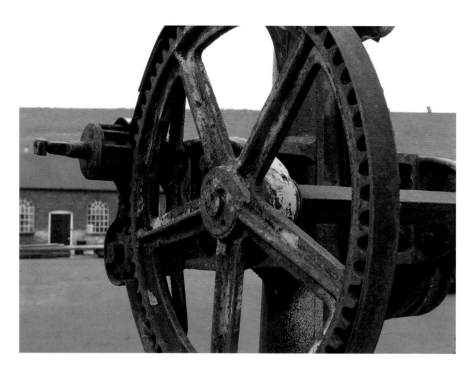

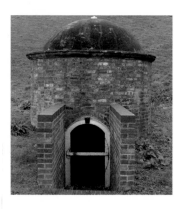

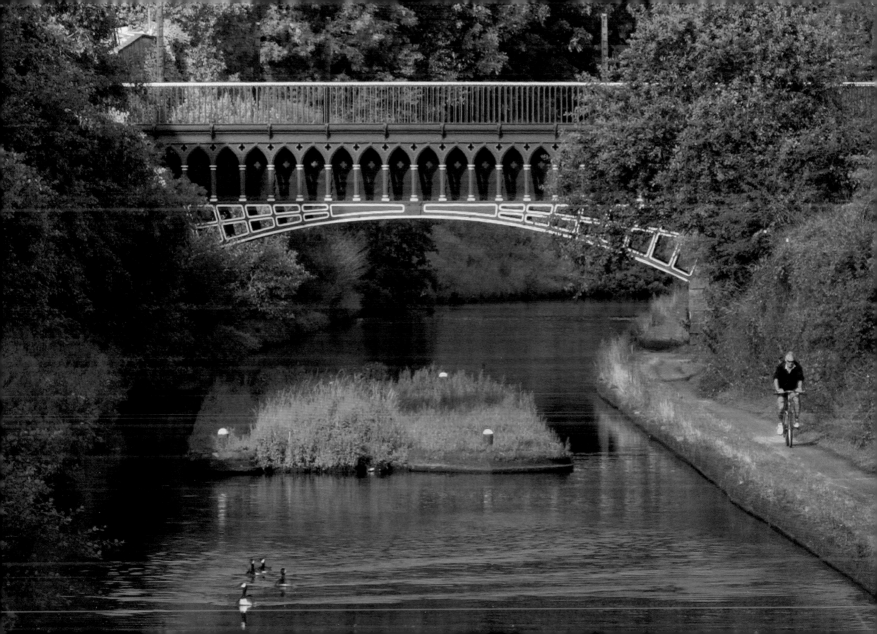

AUTHERLEY

To the west of Wolverhampton,
the new canal parts company
with the existing Stafforshire
and Worcestershire at Autherley
Junction (*right*).

Original buildings include a
warehouse and lock keeper's
cottage (*bottom left*).

The rubbing post (*bottom right*) at
the junction shows how cast iron
can be worn away by hemp rope.

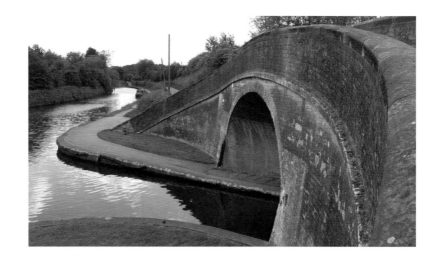

AUTHERLEY.
JUNCTION.

NANTWICH
39.
MILES.

NORBURY.

BELVIDE

Facing page and below: Three
miles north of Autherley, Belvide
Reservoir provides the water
supply at the top level of the
canal.

Half a mile further it crosses the
Holyhead road (the A5) in a cast-
iron aqueduct dated 1832 (*right*).
Telford built similar aqueducts at
Nantwich and Macclesfield.

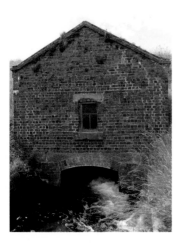

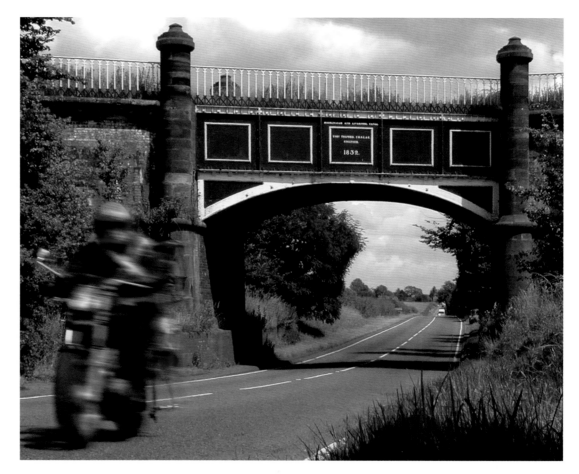

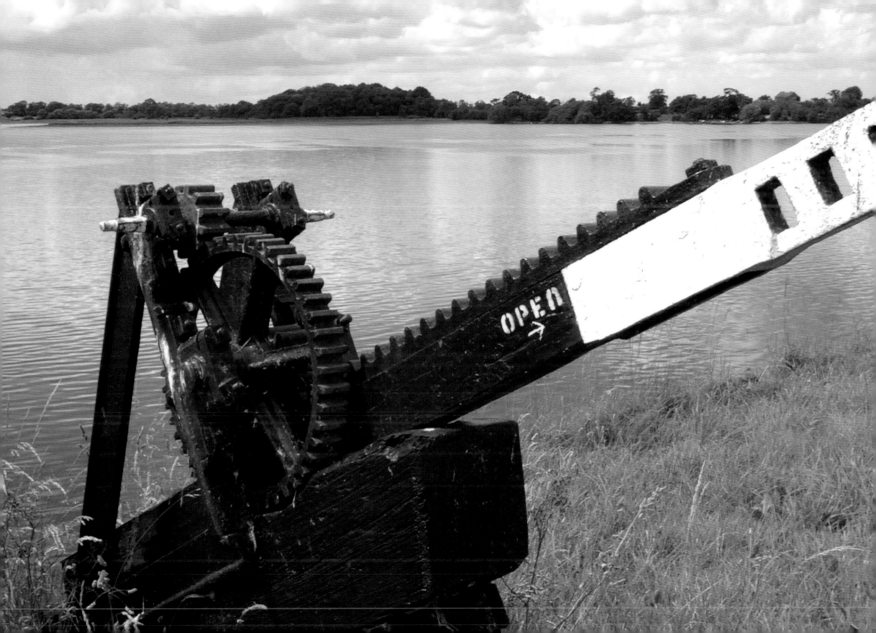

Telford's 'straight and level' policy necessitated earth-works on an unprecedented scale.

Unstable ground meant Cowley tunnel (*facing page*) had to be shortened from its planned 600 yards to only 80. Tyrley rock cutting (*below*) shows how hard some of the digging must have been.

Right: the road 'tunnel' at Shelmore is a measure of how high the bank above is, with the canal out of view on the top.

Both Shelmore and Grub Street remain unstable, costing British Waterways millions in maintenance.

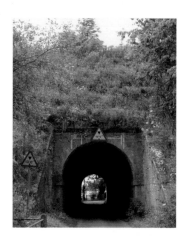

Below: A British Waterways tug pushes a barge of road-stone for towpath repair into the deep gloom of Grub Street cutting.

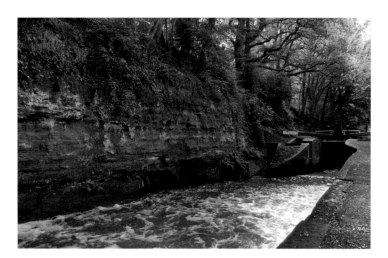

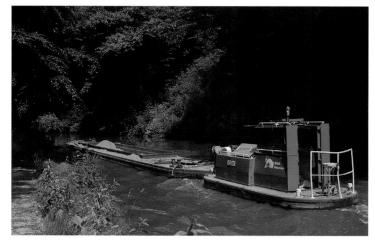

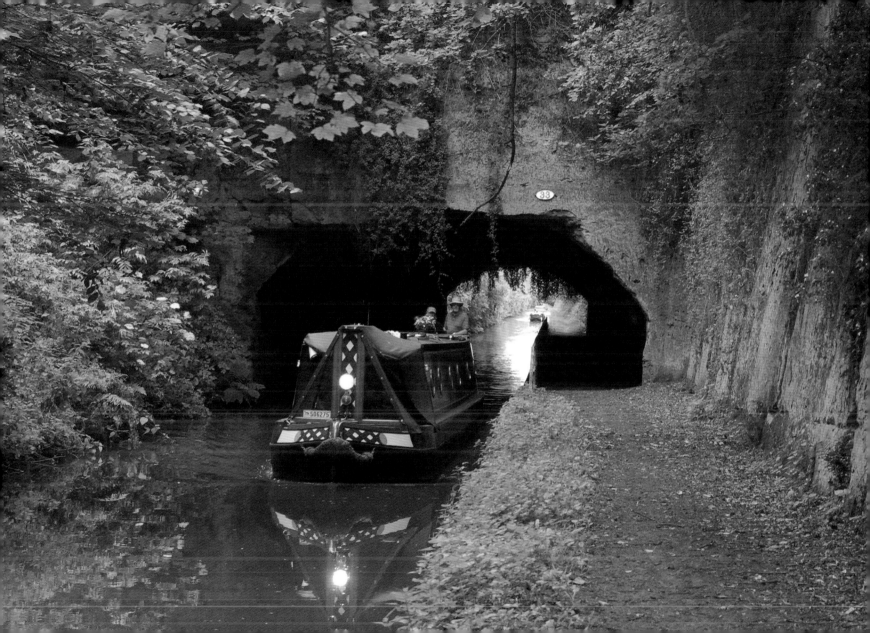

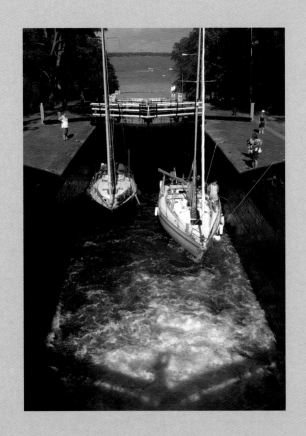

8

ADDITIONAL EXCURSIONS

Gota Canal

In 1808 a message from King Gustav of Sweden reached Telford on his travels, requesting his assistance with a ship canal linking the North Sea at Gothenburg with the Baltic near Stockholm. This was a huge project. Despite the volatility of European politics, which might have ruled out any long term co-operation, Telford spent many weeks surveying with the canal's instigator and propagandist, Count von Platen, with whom he remained a lifelong correspondent. Although he was able to offer much advice, put in place many improvements and delegate some of his own lieutenants and expert workers to help see the project through, prime credit remains with von Platen.

Gloucester and Berkeley

Telford was appointed consulting engineer to a government body, the Exchequer Loan Commissioners, in 1817. Thus he could be said to have some involvement in every major engineering project from then on. In the case of the Gloucester and Berkeley (today's Sharpness Canal), built to bypass the treacherous currents and sandbanks of the tidal Severn below Gloucester, he had a positive role both in management and in engineering.

Severn Bridges

Between 1823 and 1827 Telford was responsible for three important River Severn bridges, of cast iron at Holt Fleet and at Mythe and an unusual one of stone at Over, the Severn's lowest crossing.

South Wales road

Almost as important as the Holyhead route to Ireland, the South Wales road to Milford Haven became Telford's responsibility at about the same time as the building of Over bridge. By planning the route to Monmouth via Ross to avoid the Forest of Dean, the road missed more than the steepest terrain: Telford's surveyors, writing to him in London, as well as noting 'there is a very objectionable hill at Longhope', refer to 'intoxicated and Lawless Fellows from the Forest'. Their reports also included the plaintive pleas: 'I am doing my best but orchard trees are very thick' (probably the famous Blaisdon plum orchards) and 'I am much interrupted by the obstinacy of a farmer'.

Nene outfall

The extensive drainage networks in the East Anglian Fens, which had produced arable and pasture land from swamp, were always liable to silt up. The resulting reduced flows meant some areas were becoming permanently waterlogged. Telford worked with Rennie, and later his son, on improvements to the Rivers Nene and Ouse, and then on his own account on the New North Level.

In London

Telford's only major work in London was St Katherine Dock by Tower Bridge, constructed in 1824. In 1820 he was invited to be the first president of the Institution of Civil Engineers, and in 1821, for the first time in his life, he had a home of his own; the man who was always on tour was, at 64 years old, thinking of settling down.

Facing page: Lock on the Gota Canal at Lake Borens.

Facing page: The cruise ship *Juno* enters Skorsvik lock. The cast-iron double-lift bridge (relieved by the adjacent modern one) bears a strong resemblance to the split swing-bridge on the Caledonian at Moy. Indeed, in his book *Swedish Cross Cut*, Eric de Maré claims it was imported from England.

The canal's construction and mechanisms are the work of a Scottish consultancy, but there is a distinctly Swedish look to the lock house architecture at Berg (date stone, 1820, *top left*) and to Elin and Ebba (*above*), summer season lock keepers at Mem.

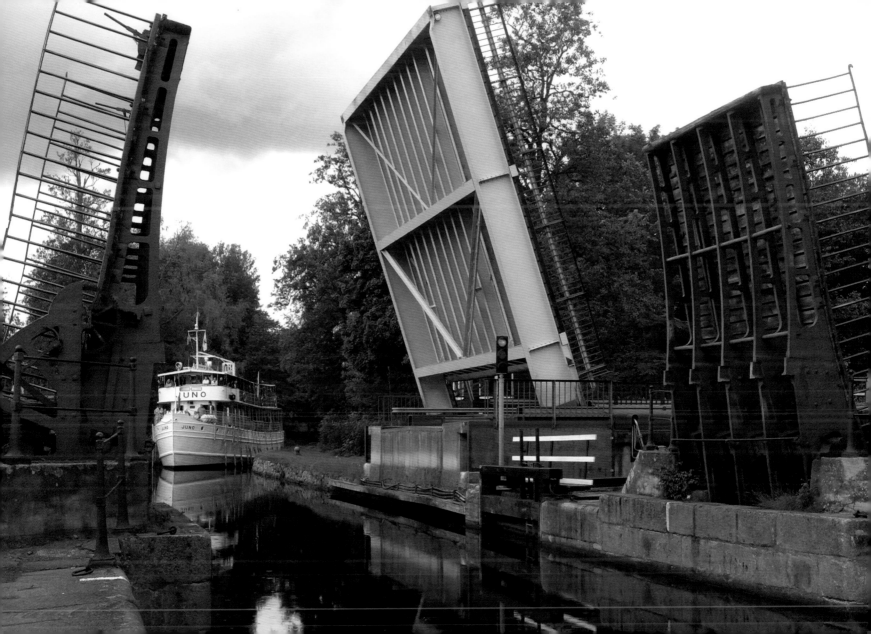

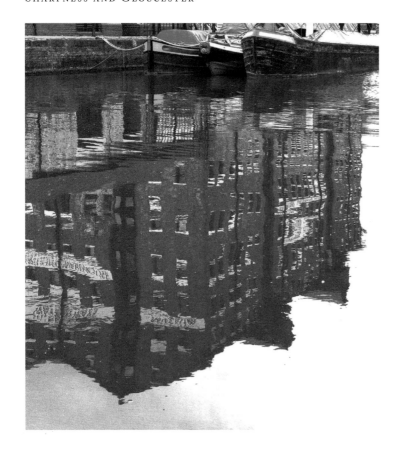

In 1823 when Telford worked on the Gloucester and Berkeley (today the Sharpness canal), Gloucester Docks were already built. Telford increased the capacity with the 'Barge Arm' (*left*, with reflection of the National Waterways Museum).

Where the Gloucester and Berkeley crossed the Stroudwater, stop lock gates were used (*right*) to prevent one company 'poaching' water from another.

Facing page: At the old tidal basin entrance at Sharpness, the harbourmaster's house, a rebuild of the original, is now used by river rescue crews.

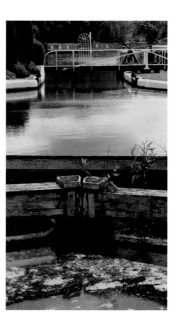

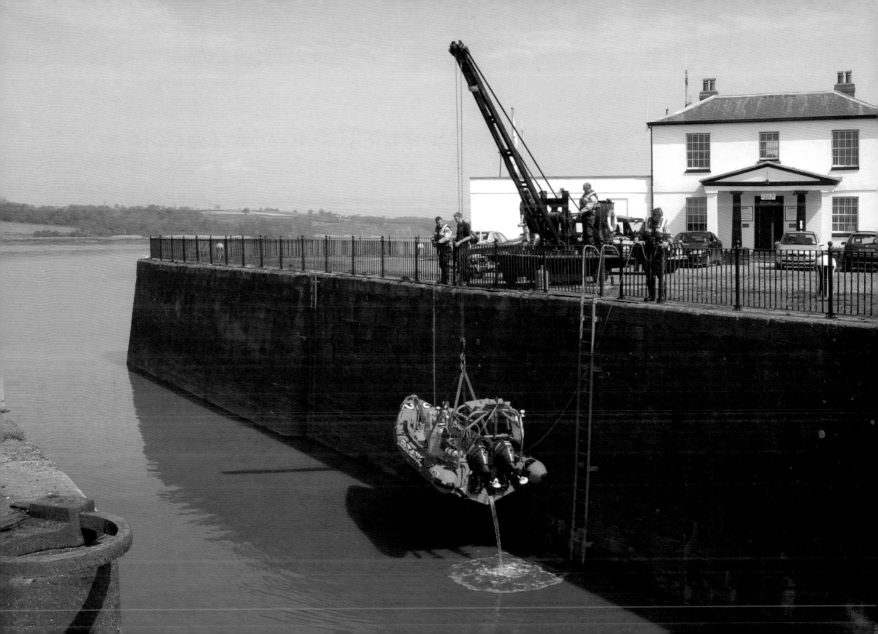

Facing page: The bridge at Mythe uses the same castings as Craigellachie. John Speck (*right*) hires pleasure boats at nearby Tewkesbury using the same wharf from which his grandfather worked as a bargeman.

Below: Holt Fleet, between Worcester and Stourport, has been substantially strengthened with concrete.

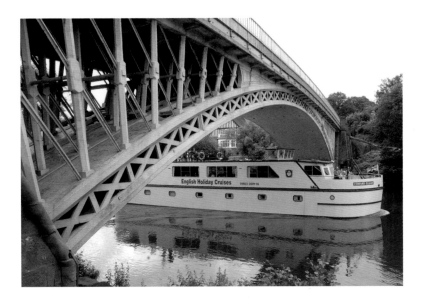

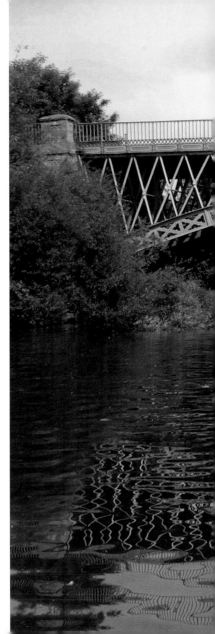

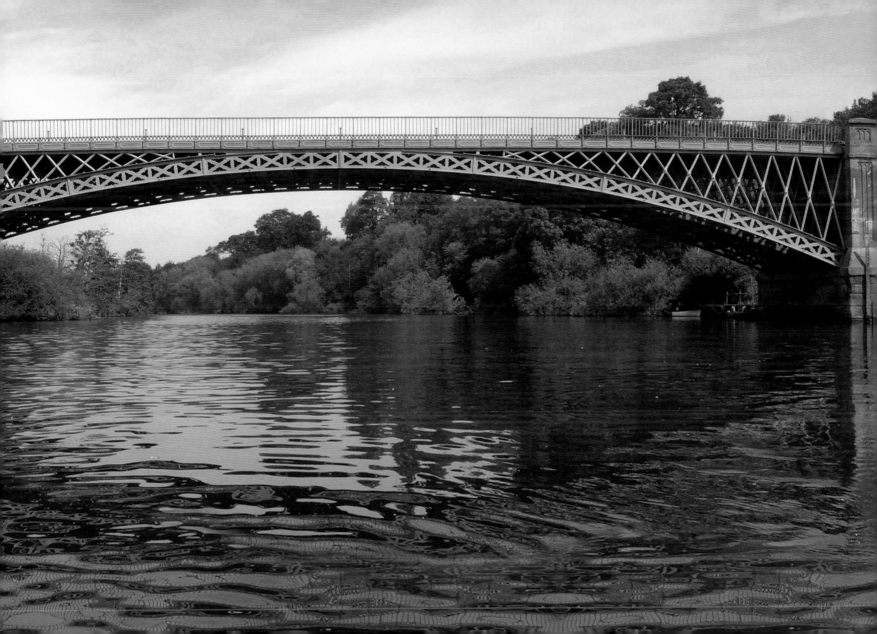

Above: Old Hill, Longhope, was 'very objectionable,' according to one of Telford's surveyors. On choosing a route to Monmouth, Telford avoided the steep Forest of Dean hills. At Huntley (tollhouse, *left*), his preferred line, the modern A40, can be seen taking a gentler grade up past May Hill towards Ross.

Facing page: The Severn Bore peters out at Over Bridge, the lowest crossing of the Severn. The unusual shape, copied from a bridge over the Seine, is said to better accommodate flooding, but not even the highest water comes up to the fluting; Telford may have had visual considerations in mind, the design appearing to give the bridge a flatter arch. Telford considered Over a failure because it sank ten inches when the 'centering' was removed – but it has sunk not another inch since.

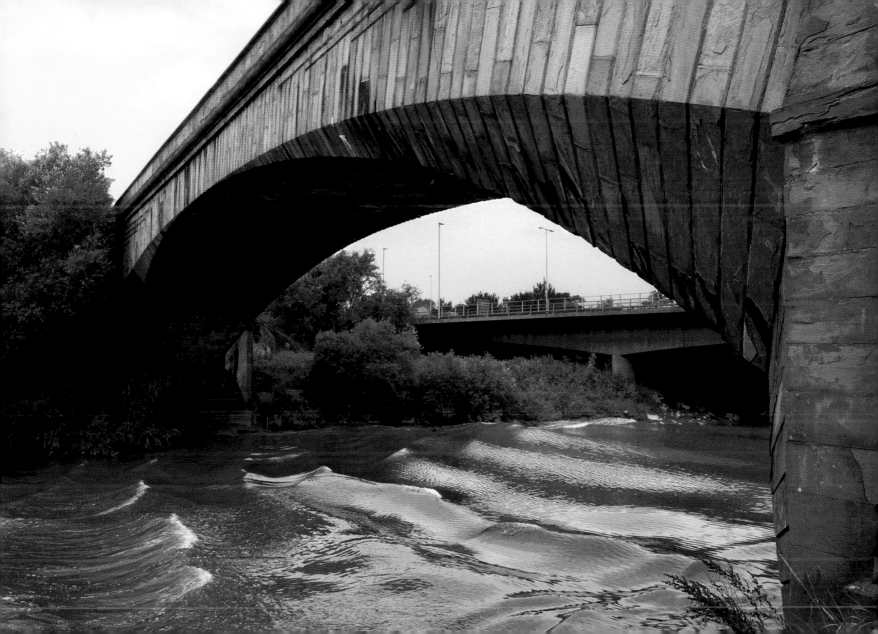

Below right: At Cloughs Cross, the start of New North Level, the original brick structure contains modern sluices.

A footbridge (*right*) at Foul Anchor, where the Level meets the Nene, is unattributed to Telford, but has the look of his work with Hazeldine.

Facing page: The Nene Outfall, where the wide wet fens meet the North Sea.

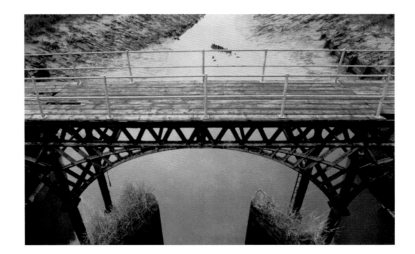

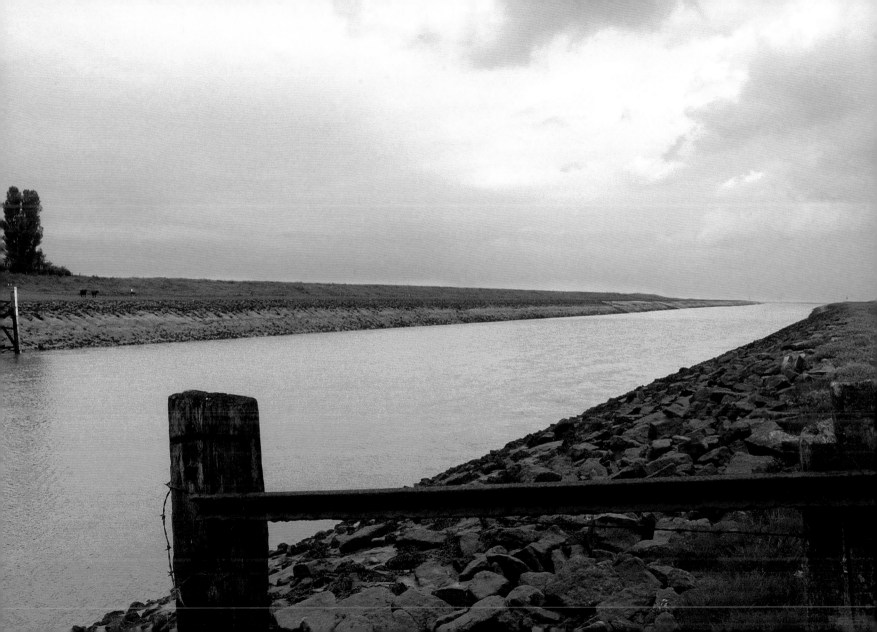

Right: Telford asked to be buried at St Margaret's, his parish church in Westminster, but his colleagues argued for Westminster Abbey as the fitting resting place for such genius. His memorial is prominent in the nave.

Facing page: Apart from Somerset House, Telford's only work in London was St Katherine Dock, where his wharves and warehouses made imaginative use of a small space. Little remains of them today.

Late in life, Telford settled in a house in Great Smith Street, London, now demolished. The plaque (*above*) is today in the Institution of Civil Engineers.

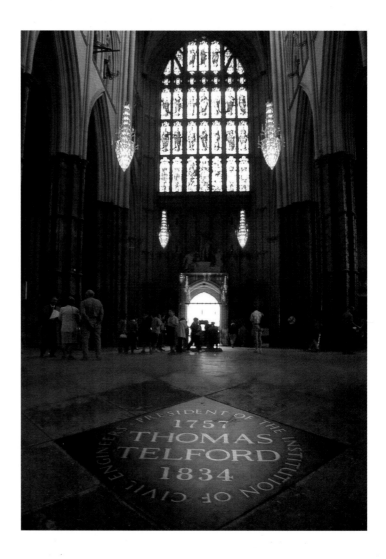

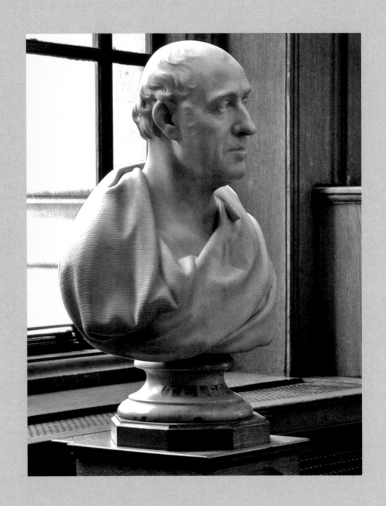

9

A PLACE IN HISTORY

In my book *The Great Brunel*, I attempted to analyse the nature of Brunel's fame by comparing him with other 'heroic' engineers of the early nineteenth century, including Telford. The most obvious comparison is with Robert Stephenson, Brunel's direct contemporary. Both sons of famous fathers, Brunel and Stephenson pushed the parameters of the nascent railway business. Perhaps Brunel's unlikely advantage in the fame game is the wonderfully enduring photographic portrait by Robert Howlett, taken at the launch of the SS *Great Eastern*. I noted that Telford, from an earlier generation, despite neither the benefit of photography nor association with the steam trains so beloved by the British public, still might be judged to have contributed more to the new profession of engineering which forged Britain's industrial revolution. There is a difference between fame and reputation.

So how did Telford fit the pattern of engineering and engineers of his own time? Our perception of him is that he was a modest man, but one happy to receive praise for his achievements (see the quote on page 6). Telford was at his most inventive in his understanding of iron; he became the master of the use of this new material, and this is what underpins his reputation. When Abraham Darby built the Iron Bridge he conceived it as if built of timber – the castings fitted together with dovetail joints such as a cabinet-maker would use. Fifty years later the world had moved on and Telford's Menai suspension bridge had links tested to double the calculated required stress before approval for use. Of course this was in conjunction with William Hazeldine, the iron founder whose works supplied almost all Telford's bridge castings.

Canal history in Britain dates back to James Brindley, who is credited with building the Duke of Bridgewater's coal-carrying canal to Manchester in 1761. Hard on his heels came John Smeaton, a prolific canal builder in the later decades of the eighteenth century, who has been called the 'first civil engineer'. Smeaton gave his name to the profession's first society, the Smeatonian, to which almost all the eminent engineers of the time belonged. In 1759 Smeaton took on William Jessop as an apprentice, thus giving a pedigree to the career of the man with whom in due course Telford would collaborate. In the last decade of the century, Jessop had become the pre-eminent canal and dock builder in Britain. Telford is also thought of as a founding father of the civil engineering profession; although he never joined the Smeatonian, he was elected first president of the Institution of Civil Engineers by his peers in 1818.

William Jessop had been appointed engineer to the Ellesmere canal in 1791, and it was almost two years before Telford joined his team. His convoluted job title was not definitive, but what seems likely is that the line of the canal, already laid out by Jessop, was honed down by Telford who, in particular was responsible for the spectacular Pontcysyllte aqueduct over the Dee. Jessop was a very busy man, concurrently building the Grand Junction (today's Grand Union) canal and West India docks, and may have been happy that his job was simply to approve Telford's initiatives.

In his autobiography, Telford conspicuously fails to make any mention of Jessop or of Jessop's involvement in both the Ellesmere and Caledonian canals. Is it possible that late in life Telford's personality shifted, or that his

Facing page: Bust of Thomas Telford in the Institution of Civil Engineers, London.

judgement became clouded? Evidence to support this theory could come from Telford's action as government adviser in dismissing Brunel's design for the Clifton Bridge project in Bristol, with the contention that no suspension bridge could be longer than his own at Menai. Probably it was not Telford's intention to take all the glory for the work he shared with Jessop but, isolated and lonely in his old age, he allowed himself to write his 'life' from selective memory rather than rigorously looking back over the papers. In his will he appointed John Rickman, the secretary of the Caledonian Canal board, to be his executor and charged him with editing the book; this took several years and may also have seen a change of emphasis. Charles Hadfield, the authoritative canal historian, provides a full and thought-provoking account of these issues in his book *Telford's Temptation* (see Bibliography, page 160), but his conclusion – that Telford wanted undivided glory – are dismissed by all modern authorities.

Telford's life was so work-centred that he never married, and indeed never had a home of his own until late in his career, when he established himself in Westminster. His private life seems to have been virtually non-existent; as a young man his chief diversion was writing poetry, but that faded, although he continued to enjoy the lifelong friendship and esteem of the poet Robert Southey. His prime times were spent touring his many projects, all running concurrently in the hands of his capable deputies. Their loyalty to him speaks for Telford's character.

With due respect to William Jessop and John Rennie, both fine engineers with a high reputation but little fame, Thomas Telford was, in my opinion, the outstanding engineer of his generation. While first and foremost he must be seen as an inventive genius, he was able to combine his brilliance with the ability to remain steadfast and methodical under pressure. His pre-eminence in the new structural use of iron underpins the claim; further, the qualities that made him a leader of men, and gave him the understanding of social needs which he was in a position to help meet, ensure that he should be raised to the highest pedestal.

Index of Placenames

Acknowledgements

Thanks for help and advice to:

Professor Angus Buchanan
Mike Chrimes
Neil Cossons
Jonathan Lloyd
Paul Manning
Jim McKeown
Rev. Henry Morris
Steve Morris
Lindsey Porter
John Powell
Michael Taylor
Barrie Trinder

Thanks also to all who agreed to appear in the book, and to:

AB Gota Kanalbolag
British Waterways
Church of Scotland
Institution of Civil Engineers
Severn Area Rescue Association
Shropshire Union Society
Ullapool Museum
Tobermory Museum
Wick Heritage Centre

Bibliography

Bracegirdle, B. and Miles, P., *Thomas Telford*
Cossons, N. and Trinder, B., *The Iron Bridge*
Cragg, R., *Civil Engineering Heritage*
Dunlop, J., *British Fisheries Society 1786–1893*
Gibb, Sir Alexander, *The Story of Telford*
de Maré, E., *Swedish Cross Cut*
Quartermaine, Trinder, Turner, *Thomas Telford's Holyhead Road*
Quartermaine, *Telford*
Rickman, J. (ed.), *The Life of Thomas Telford*
Rolt, L.T.C, *Thomas Telford*